MIRÓ SELECTED PAINTINGS

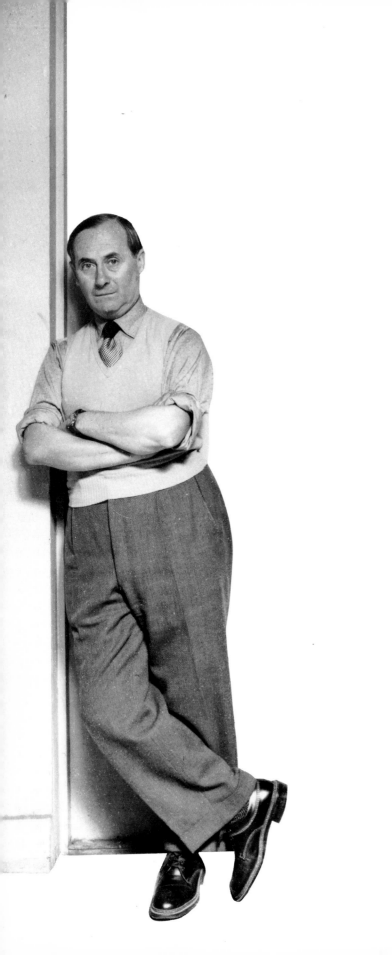

Charles W. Millard

MIRÓ
SELECTED PAINTINGS

Hirshhorn Museum and Sculpture Garden, Smithsonian Institution

Smithsonian Institution Press, Washington, D.C., 1980

Cover: Miró in Carl Holty's studio, New York, 1947
Detail of photograph by Arnold Newman © Arnold Newman

Exhibition Dates
Hirshhorn Museum and Sculpture Garden, Smithsonian Institution,
 Washington, D.C., March 20–June 8, 1980
Albright-Knox Art Gallery, Buffalo, New York, June 27–August 17, 1980

Library of Congress Cataloging in Publication Data
Hirshhorn Museum and Sculpture Garden.
Miró: selected paintings.
Catalog of an exhibition held at Hirshhorn Museum and Sculpture Garden, Mar.
20–June 8, 1980, and at Albright-Knox Art Gallery, June 27–Aug. 17, 1980.
1. Miró, Joan, 1893– —Exhibitions. I. Miró, Joan, 1893– II. Millard, Charles W.
III. Albright–Knox Art Gallery.
ND813.M5A4 1980 759.6 79-9662

ISBN 0-87474-638-8
ISBN 0-87474-639-6 (pbk.)

CONTENTS

LENDERS TO THE EXHIBITION

Mr. and Mrs. James W. Alsdorf,
 Chicago
Mr. and Mrs. Armand Bartos,
 New York
Mr. and Mrs. Gordon Bunshaft,
 New York
Carimati Collection, New York
CPLY Art Trust, New York
Ernest Hemingway, New York
Annette Mandel Inc., Great Neck, New York
James Johnson Sweeney, New York
Four anonymous lenders

Albright-Knox Art Gallery, Buffalo,
 New York
The Art Institute of Chicago
The Detroit Institute of Arts
Fogg Art Museum, Harvard University,
 Cambridge, Massachusetts
The Solomon R. Guggenheim
 Museum, New York
Hirshhorn Museum and Sculpture
 Garden, Smithsonian Institution,
 Washington, D.C.
The Meadows Museum, Southern
 Methodist University, Dallas
The Museum of Modern Art, New York
New Orleans Museum of Art
Philadelphia Museum of Art
The St. Louis Art Museum
The University of Iowa Museum of Art,
 Iowa City
Wadsworth Atheneum, Hartford,
 Connecticut

Pierre Matisse Gallery, New York
Perls Galleries, New York
E. V. Thaw and Co., Inc., New York

FOREWORD

There has never been any doubt that Miró enjoys a leading position among the generation of artists who established modernism in the early part of this century. But it has become increasingly evident that Miró's place is alongside the most fertile of those giants—Picasso and Matisse. The astonishing fact that Miró, in his eighty-seventh year, is still productive and his work as youthful and innovative as ever is a phenomenon worthy of celebration.

There has always been an appreciative American audience for his art—a factor in our decision to limit this exhibition to works in American public and private collections only. It would be interesting to speculate on those qualities in Miró's work that make his art so popular on this side of the Atlantic, for we seem to be especially susceptible to the wit and fancy evident in even his earliest works. If our national character can be seen as being simultaneously pragmatic and visionary, then perhaps we have a natural affinity for these spirited canvases in which the unreal and allusive achieve such vitality and substance.

In my student days I encountered my first Miró, the wonderful *Dog Barking at the Moon* (catalog number 15) in the Gallatin Collection, then housed at New York University. This delightful amalgam of humor, fantasy, and high art never lost its fascination and turned

me into an ardent Miró fan. It is partially the memory of this youthful encounter, overshadowed as it is by the more significant purpose of this exhibition, that gives me such pleasure in thanking those institutions and collectors who were willing to part, even temporarily, with their precious paintings, and the Museum's staff for putting it together with their usual dedication and expertise. .

Abram Lerner
Director

ACKNOWLEDGMENTS

First and foremost, I would like to acknowledge the generous cooperation of the lenders to this exhibition, who have been good enough to part with their valuable and fragile treasures for its duration. Among those who were most helpful during the preparatory stages are the dealers through whose hands Miró's paintings have passed, some of whom are also lenders. These include William Acquavella, Harold Diamond, Richard Feigen, Stephen Hahn, Klaus Perls, and Eugene Thaw. Pierre Matisse, Miró's principal dealer in the United States, and the staff of his gallery are due special thanks for their cordial assistance. Christopher Burge of Christie's and Ian Dunlop of Sotheby Parke Bernet have also been extremely cooperative, as has Arnold Newman. Research for the catalog has been materially assisted by Elisabeth Holty; Josep Lluis Sert; Mary Maynard of Harvard University; Janette B. Rozene of the Museum of Modern Art, New York; Grace Kean of the Cincinnati Art Museum; Frances Forman of the Cincinnati Historical Society; and William Treese of the University of California at Santa Barbara. Here in Washington, LeRoy Makepeace, of the Smithsonian Institution's Office of International Programs, and David Scott, of the National Gallery of Art, have been generously helpful.

To name those who have assisted the exhibition within the Hirshhorn Museum would be to name the entire staff. One must, however, acknowledge Abram Lerner, Director, and Stephen E. Weil, Deputy Director, as well as Laurence Hoffman, Conservation; Nancy F. Kirkpatrick, Administration and Museum Support Services; Edward Lawson, Education; Douglas Robinson, Registrar; Joseph Shannon, Exhibits and Design; Captain Kenneth Thomas, Guards; and Frank Underwood, Building Services. Special thanks are due Bette Walker, who typed the manuscript of the catalog and who, in general, manages to maintain order in my curatorial life, and Nancy Grubb, who did her accustomed fine job of editing the catalog and supervising its production despite a crushing schedule.

Last, and in many ways most important, my thanks to Judi Freeman who, in most essential respects, produced the exhibition from start to finish.

C.M.

MIRÓ

Charles W. Millard

The genesis of the present exhibition and catalog was my desire to write critically about Miró's painting and to present a retrospective selection of that painting to an audience not heretofore widely exposed to it. While Miró's name is familiar everywhere, his painting has been seen in quantity in this country only in New York. Although individual works of great quality are to be found in almost all major American museums, as well as in private collections in many cities (notably Chicago), it is a curious fact that few museum exhibitions of his painting have been mounted outside of Manhattan. None has ever taken place in Washington or Buffalo, for example. The decision to limit this exhibition to American works was taken not only because of the quality and variety of the available material, but also to keep the financial and logistical aspects of the exhibition within bounds. The number of works reflects the space available in the Hirshhorn Museum for loan exhibitions. The specific content of the exhibition results, as usual, from a confrontation of the ideal with the real. Many works that I had wanted to include were unavailable for loan, for reasons either technical or personal. Since, however, my main object was to represent the quality of Miró's painting rather than its protean variety, enough first-rate works could be found to constitute an exhibition that will, I hope, both show the nature of his development and provide ample demonstration of his accomplishment.

Among Miró's few surviving student drawings, *Design for a Jewel* (fig. 1) of 1908 is notable for what it says about the artistic sensibility of its author. Conceived in the shape of a serpent biting itself and focused on the large stone that represents the serpent's eye, the *Design* is, as suits its purpose, highly decorative in its sinuous configuration. Not far removed in time from the extravagances of Art Nouveau, which had a particular efflorescence in Miró's native Catalonia, the *Design* clearly reflects that movement's preference for tendrillike configurations. By way of contrast to the general decorative nature of the *Design*, the open jaws with their huge teeth seem particularly aggressive, and the oversized stone of the eye borders on vulgarity. These apparently contradictory strains are modulated in the drawing by the fluid yet regular, almost geometrical, patterning of the serpent's body, which manages to reinforce both of them while simultaneously binding them together in pictorial tension.

By 1914 Miró had passed beyond the exercises of his student years to works of greater ambition, and the range of his artistic references expanded in scope and quality accordingly. The *Landscape, Montroig* [1, fig. 2]* of that year reflects the interest in the

*Numbers in brackets refer to catalog entries.

Fig. 1
Miró
Design for a Jewel, 1908
Fundació Joan Miró, Barcelona

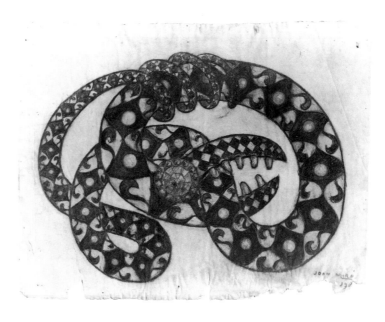

Fig. 2
Miró
Landscape, Montroig, 1914 [1]

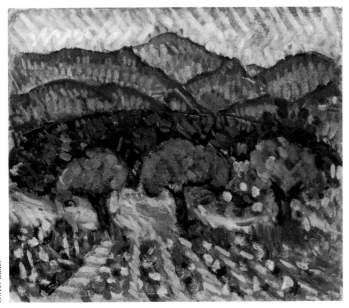

Oliver Baker

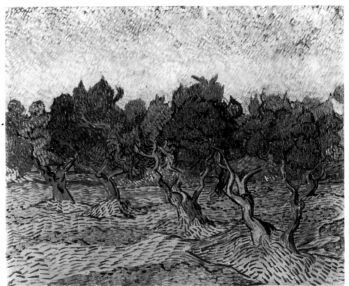

Fig. 3
Vincent van Gogh (Dutch, 1853–1890)
Olive Orchard, 1889
Rijksmuseum Vincent van Gogh, Amsterdam

work of Van Gogh that the artist has always acknowledged. Not only is its composition clearly indebted to the older master's late landscapes (see fig. 3), but the *tachiste* paint application, most apparent in the sky, and the tendency toward careful division both of compositional elements and of types of brushstroke evidence how compelling Miró found Van Gogh's style. The fact that several of the pictures attributable to 1914–15 are unsure in composition or dark-valued, almost muddy, in color suggests how much Miró had need of Van Gogh's structural and coloristic clarity, not to mention the sympathy one aspect of his artistic personality must have felt with the intense and anguished sensibility expressed in the Dutchman's work.

By 1916–17 increasing compositional clarity—sometimes dependent on compartmentalization of forms—and gradual lightening of color suggest that Miró had thoroughly internalized his art historical lessons, assisted by the more contemporary achievements of Fauvism. The rounded forms of *The Path, Ciurana* (Tappenbeck collection, Mouzay, France), of 1917, clearly reflect the writhing masses of Van Gogh's last pictures, while its color harmonies owe a substantial debt to the blue-green-ocher triad favored by Impressionism and transmitted to the twentieth century in the work of Cézanne and others. By 1917 Miró was sufficiently confident to play original variations on these themes, and in *The Path* the warmer tones are brought to the foreground and fragmented, while a large area of intense, uninflected blue at the top represents the sky. The result contradicts the usual effect of advancing warm and receding cool tones, bringing the top of the composition forward and flattening the entire picture. *The Village, Prades* [4], also of 1917, uses the same general coloristic pattern in a composition that is at once stronger and less unified than that of *The Path*. The forms of the village in the background are modulated internally by color changes that produce a curious warping effect. The resulting softness, apparent also in the modulated sky, is played off against the bold decorative patterning of the foreground, with its sequences of inverted chevrons and arched or serpentine parallel lines. Each of the lines or chevrons within these sequences is clearly differentiated from the others by color contrast, and Miró makes much of the oranges, purples, and other off-colors that began to have an important place in his work at this time. While formal clarity and discreteness seem to have been almost obsessions with him during the late 'teens, his increasing use of mixed colors helped unify his pictures.

The year 1918 was one of particular importance for Miró's painting. It was then that the human figure consistently joined landscape and still life as a significant subject for him, and more important, it was then that his art first declared itself as one of major

Fig. 5
Miró
Portrait of Juanita Obrador, 1918 [7]

Fig. 6
Vincent van Gogh (Dutch, 1853–1890)
Portrait of Trabu, 1889
Private collection

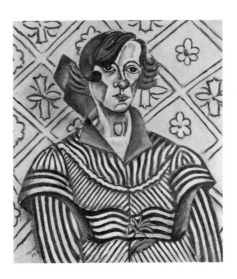

Walter Drayer

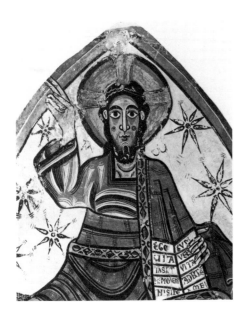

Fig. 4
Catalan, 12th century
Christ in Majesty (detail)
Courtesy Museum of Fine Arts, Boston
Marie Antoinette Evans Fund

quality. The strains discernible in *Design for a Jewel,* which later developments identify as decorative and expressionist, continued to exist side by side in his work, accommodated in increasingly subtle ways but never entirely synthesized. In *Portrait of Juanita Obrador* [7, fig. 5], for example, the expressive distortions of the face—almond eyes, hollow cheeks, and bulbous nose—are modulated with color and played off against the powerful striped patterning of the dress. The strength of both face and dress, in turn, helps maintain three dimensions by exerting pressure counter to that of the heavily patterned and high-valued wallpaper of the background, so reminiscent of that dear to Cézanne, another of Miró's idols. The whole effect recalls that of Van Gogh's *Portrait of Trabu* (fig. 6) where, however, the background pressure is exerted not by patterning but by intensity of color and obvious brushwork. The *Juanita Obrador* is characterized by a peculiar reversal in which the loosely patterned and almost flesh-colored ground seems more human than the harsh, aggressive figure. The whole is drawn together by a toning down of the white stripes of the dress, in part with a pink related to that of the ground. Miró's interest in flattening his compositions during the years around the First World War is evidenced not only in his use of painted pattern, but also in the introduction of collage elements both to bring backgrounds forward, as with the Japanese print in the *Portrait of E. C. Ricart* (Schoenborn collection, New York) and the wallpaper in the *Portrait of Ramon Sunyer* [6], and to assert the picture plane, as with the card pasted to the *Still Life with Coffee Mill* [5]. His debt to Cubism is particularly obvious in the latter case.

Miró's interest in Cubism at this time seems largely to have been centered on the sort

Fig. 7
Miró
Standing Nude, 1918 [8]

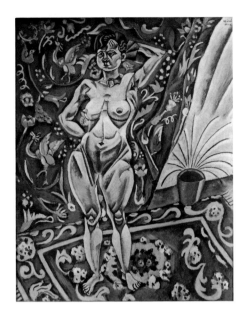

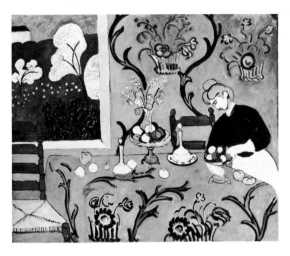

Fig. 8
Henri Matisse (French, 1869–1954)
Harmony in Red, 1908–9
Hermitage Museum, Leningrad
© S.P.A.D.E.M., Paris/V.A.G.A.,
New York

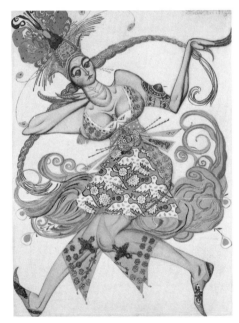

Fig. 9
Leon Bakst (Russian, 1866–1924)
The Firebird, 1913
Collection, The Museum of Modern Art,
New York
The Joan and Lester Avnet Collection
© S.P.A.D.E.M., Paris/V.A.G.A., New York

of provincial or peripheral—not to say decorative—Cubism that characterizes the work of artists such as Bakst. This is particularly obvious in Miró's first major masterpiece, the *Standing Nude* of 1918 [8, fig. 7]. Cubist-related patterns are used to render the figure, which is played off against an aggressively patterned and brightly colored ground in much the same way that the Russian's ballet designs juxtapose flat, patterned renderings of costume with Cubistically distorted three-dimensional human forms (see fig. 9). More important affinities with the *Standing Nude* are to be seen in Matisse's "Islamic" pictures of around 1910, such as *The Painter's Family* and *Harmony in Red* (fig. 8). Here, figures rendered rather differently from Miró's are seen against patterns fully as dominant in color and design as those of the younger master, an effect that has roots in the work of Degas and Vuillard. Moreover, the *Standing Nude* and the Matisse works in question both exploit a spatial compression produced by downward views of the floors on which the figures stand. Although the overall impression of the Miró is one of extreme flatness, almost all the forms are subtly modulated, reinforcing the richness of the whole. The rug is rendered in daring contrasts of peach and maroon, while the background juxtaposes brilliant red, blue, green, and yellow, often intensified with other shades of the same hue. Since Miró's color has a stridency not to be found in the more polished achievements of Matisse, he is obliged to insert a delicate plant pattern against a neutral ground at the right so that the picture as a whole can breathe. The extreme clarity with which each element of Miró's composition declares itself, and his apparent effort to give every passage in the *Standing Nude* equal pictorial weight, suggests another source for his visual effects.

In addition to Matisse, to Cézanne and the Cubists, and to Van Gogh and the Fauves, Miró was certainly attracted to such impressive accomplishments of early medieval art as the fresco cycles at Tahull and Urgell in his native Catalonia (see fig. 4). Although the visual conventions of these cycles are at times surprisingly congruent to those of early

twentieth-century art and their influence on Miró's painting is, at least partly for that reason, difficult to specify, the stylization of the eyes, nose, and mouth in works such as the *Juanita Obrador,* not to mention its overall patterning and other devices, clearly suggests how thoroughly and broadly Miró had absorbed the artistic environment of his youth.

To speak of influence in the work of Miró is neither to denigrate that work nor to explain it, or any part of it, away. The artistic process that goes by the name of influence is important not in the fact that one artist takes ideas or effects from another but in what the expropriating artist does with what he takes. Any young artist looks naturally to older masters and to his contemporaries to find work outside himself to which he can respond, work that confirms him in his own ideas, freeing him to pursue his own path by showing him not only that such a path exists but also that it leads in a viable direction. Influence is, thus, partly an act of recognition, an objective confirmation of one's own inner being, and partly a way in which the creative temperament takes courage, finding role models in the outside world by means of which it confirms the validity of its own existence. As an artist matures, this process continues and, indeed, his openness to the world around him—his willingness to be influenced—can be a gauge of his maturity. If in his youth an artist tends to be influenced by making works that look like those of another, or to exploit effects identified with another, that is merely a shortcut to his own artistic identity, an aid to working through the important professional problems that confront him. In his maturity, influence may take far subtler form and the transformation of borrowed material can be so instantaneous and so complete as to be invisible. To what degree and by whom an artist is influenced are clues both to his personal predilections and to his aesthetic aims and ambitions. What he does with that influence illuminates the scope of those aims and ambitions as well as the quality of his ultimate achievement.

In 1919 Miró made his first trip to Paris. Having absorbed everything his native land, even a center as cosmopolitan as Barcelona, could teach him—summed up in the work of 1918, particularly the *Standing Nude*—he, like all artists of major talent and ambition, was drawn to new challenges in what was then the art capital of the world. Although the 1919 trip was brief, its effect was profound, and he returned the following year to take up what was to be semi-permanent residence in France. While Miró was to find his professional home in the Paris art world, its immediate impact on him was so stunning that his painting output declined noticeably for a period of about four years while he looked, explored, experimented, and absorbed.

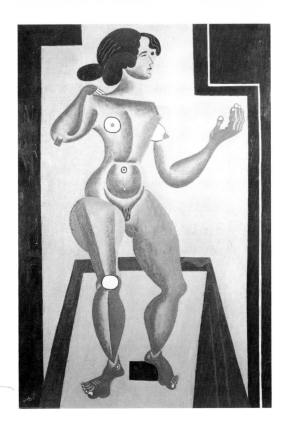

Fig. 10
Miró
Standing Nude, 1921
Alsdorf Foundation, Chicago

The table-top still lifes of this period show him assaying with more accuracy the effects of Cubism—Synthetic Cubism in the 1920 *Spanish Playing Cards* (Cowles collection, Minneapolis) and a combination of Synthetic and Analytic Cubism in *Horse, Pipe, and Red Flower* (Miller collection, Downington, Pennsylvania) of the same year, a picture of great compositional complexity. The 1921 *Standing Nude* (fig. 10), its simplified but modulated figural forms played off against an uninflected background whose geometrical shapes are clearly generated by the overall size and shape of the canvas itself, brought Miró as close as he was to come to the borderline between Synthetic Cubism and Purism. The figure's face exploits the simultaneous frontal and profile views so often used by Picasso; the breasts, separated by the width of the body, are seen from different angles; and the hands are exercises in representing the same anatomical feature according to different pictorial conventions. That Miró struggled to refine the picture is obvious from the decorative background elements, some in contrasting colors, that were painted over and are now reemerging as pentimenti. In its finished form, the color scheme of the painting is austere almost to the point of monochrome. Further essays in reductionism are to be seen in such works as the *Ear of Grain* (1922–23, Museum of Modern Art, New York), which also experiments with creating a composition large in scale but small in format. The most prophetic of Miró's works during this period, however, is *The Farmer's Wife* of 1922–23 (Duchamp collection, Neuilly), a drastically simplified work in which the reduction of certain elements to abstract notations suggests Miró's pictures of the middle and late twenties. Similarly, the monstrously exaggerated feet of the eponymous figure foreshadow the free reign Miró was soon to give his fantasy.

The most important of Miró's works at this time is *The Farm* of 1921–22 [9], which synthesizes the concerns of the early Paris period, as the 1918 *Standing Nude* did those of the Barcelona years. In this great work, two large tonal areas are established, warm for the foreground and cool for the sky. Although certain colors register quite strongly—notably blue and red—there is a tendency toward coloristic subtlety evidenced in the graying of almost all the hues. What would normally be highlights are toned down—the moon grayed and the architecture putty colored—while what would normally be the deepest darks are similarly ameliorated—the leaves of the eucalyptus, for example, which seem black, are in fact dark green. Moreover, large color areas are suppressed—the wall of the house at the left covered with moss and fissures, the sky seen behind the eucalyptus fanning out across it. A tendency toward compartmentalized pattern is similarly suppressed, as in the cornstalk rising at the lower left to soften the regular ridges of the field. All these devices work to unify what otherwise consists of an accumulation of discrete and clearly defined elements, a picture in which there is diminution but no real recession and one in which shading is used to modulate small areas or individual objects but not as a means of overall interconnection. In sum, *The Farm* is, as opposed to the *Ear of Grain,* an extraordinary achievement in making a large composition on a small scale, in accreting a work that must be read from point to point, giving equal pictorial weight to all its elements. Considered alongside other pictures of the period, it gives early evidence of Miró's since amply demonstrated capacity to work successfully on vastly different scales. This capacity is a corollary to, or perhaps an extension of, the two strains in his work previously identified as expressionist and decorative. The smaller, enumerative compositions tend toward the expressionist and give vent most easily to Miró's fantasy, while the larger scaled, more simplified works tend to the decorative and allow broader scope to purely pictorial considerations such as color and abstracted shape.

By 1924 Miró seems to have mastered the lessons French painting had to teach him—in part those of Cubist structure and in part those of coloristic refinement—and during the next three years there issued from his brush more paintings than had been produced in the previous ten. Two of these relate directly to *The Farm* and are important both for their inherent quality and for the polish they brought to the expressionist-enumerative aspect of his art. They are *The Tilled Field* of 1923–24 [10], and *Carnival of Harlequin* of 1924–25 [12]. The former retains many of the elements of *The Farm*—houses, trees, and animals—while simplifying the background into two flat, high-valued color areas interrupted at the right by a wedge of darker tonality.

Certain of the picture's elements are placed directly on the horizon created by the division between these two areas, while others rise up through it without concealing it in the way *The Farm's* buildings conceal its horizon. Although some of the objects represented are shaded, shading is always internal to them and patterns such as those of the furrows at the far right and the vertical striations in the left center foreground are consistently contained within the clearly defined limits. In *Carnival of Harlequin* the background is further simplified, while the remaining pictorial elements are reduced in size and multiplied in number. Since these elements are less naturalistic than those in *The Tilled Field* they tend less easily to be subordinated one to the other, moving in a freer and more detached way across the surface of the canvas. Although the background is grayed and unifying in nature, the colors of the small objects seen upon it tend toward primary blue, red, yellow, and white, giving a staccato pictorial liveliness that well conveys the spirit of the title.

While the expressionist aspect of Miró's art, embodied in the fantasy of his forms and their juxtapositions, was coming to perfection, the rival decorative tendency struck out into new territory in one of the most extraordinary developments in twentieth-century painting. Beginning in 1924 there appear canvases, of which the *Portrait of Madame B* [11] is typical, in which the background is a single color, frequently yellow but sometimes beige, gray, or another neutral hue. These monochrome grounds are inflected by being brushed on in varying densities, and representational and abstract shapes, including letters, words, and the finest of black lines, are floated against the atmospheric result. The shapes and lines used are wholly contained within the confines of the canvas, unlike those in *The Farm* and related pictures, and are manipulated to provide a web of pictorial incident through which the background color fields can be seen and by means of which they are controlled.

By 1925 Miró realized that pictorial incident could be reduced, allowing uninterrupted hue to speak more effectively, if the colors of his grounds were more intense, more obviously applied, or both. Blue and brown had by then become his most common ground colors, while the floating shapes tended to be executed in a thinly brushed white, sometimes shaded into the ground at one or more sides, with touches of red and yellow. The fine black lines that had characterized the earlier pictures continued to appear. The danger for such compositions was that the pressure exerted by the powerfully actuated grounds would swallow up the smaller forms, a weakening that Miró almost always managed to avoid. The only precedent for the simplicity, openness, and scale of the best of these impressive decorations is to be found in

Matisse's painting of the late 'teens, but it is a remote precedent indeed since Matisse had used his coloristic breadth to wholly different effect. Perhaps the greatest of these pictures by Miró is *The Birth of the World* [13], a monumental composition in which a thin gray ground is washed on, leaving ample evidence of facture, including extensive dripping. Across this aquatic atmosphere are floated an eccentric red circle with a white tail, a black triangle, and other shapes and lines that manage by some minimal magic to create an overwhelming visual and emotional impact. With this and related pictures one realizes how completely Miró had mastered French painting. Indeed, it becomes clear that the dual strains in his work identifiable from the beginning can, in his maturity, be classified as French and Spanish, the former corresponding to the decorative tendency toward simplicity, the latter to the expressionist tendency toward multiplicity. Catalan that he is, Miró looks to two artistic traditions, both of which he commands. Exceptionally for a great artist, he has resisted synthesizing these traditions, maintaining them in relative purity side by side down to his most recent work. In this context, his attraction to the work of the French Dutchman, Van Gogh, takes on special significance.

Throughout 1926 and 1927 Miró was preoccupied with his recent bold pictorial discoveries. A series of landscapes represents his only attempt to paint in his expressionist manner during this time, and even they are heavily decorative in feeling. Divided horizontally into two zones, they have few elements, frequently animal, imposed on them. In *Dog Barking at the Moon* of 1926 [15], there is only a ladder, joining the upper and lower zones without interrupting them, in addition to the dog and the moon. The dark tonalities of *Dog* are further developed in *Nude* [14] of the same year, whose shapes are prophetically elaborated across a flat black ground. Like *Dog*, *The Hare* (1927, Solomon R. Guggenheim Museum, New York) suppresses surface incident, superimposing a dotted spiral, which occupies space without defining an object, on its two pictorial zones. The figure of the hare itself is modulated coloristically, not so much to create three-dimensional form as to moderate its pictorial presence and to spark the relatively somber ground, consisting of an intense orange and a dark, rich purple thinly applied over another similar hue. This sensuous colorism is most striking in the *Landscape* of 1927 [16], the lower zone of which is a deep, velvety blue, the upper a rich red. Little is necessary in addition, and the small, widely separated shapes of the rabbit and the flower provide all the punctuation required.

During 1927 Miró produced a series of pictures with mid- to dark-valued brown grounds, looking like unpainted canvas, on top of which large white forms were

brushed, usually with the addition of a few fine black lines. The best of these, such as *Circus Horse* [17], show how little pictorial incident he needed to produce a powerful aesthetic effect. He also reversed his tonalities and painted several works with dark shapes against white grounds, many without apparent naturalistic reference and titled simply *Painting on White Ground.*

Having, in four years of prolific work, brought himself to the very borders of abstraction—some would say, having passed beyond them—Miró apparently felt the need of refreshment from nonvisual sources, and his output of painting dropped dramatically between 1928 and 1930 as he involved himself in the activities of the Surrealists. Although he never subordinated his art to Surrealist principles, Surrealism seems to have provided the fresh impetus he needed and to have freed him to follow new paths.

The immediate pictorial result of Miró's contact with Surrealism is a small group of pictures based mostly on seventeenth- and eighteenth-century compositions [see 19]. It is as if these older works were useful to him in evoking form, much the way Leonardo, in the comment made much of by the Surrealists, had suggested that the creative imagination could be spurred to find a landscape in a color-spattered wall. Miró's pictures maintain the flat, horizontally divided backgrounds of the landscapes, but impose on them a bewildering variety of shapes. Those shapes, generally biomorphic and referring to human or animal forms, are rendered in fairly saturated colors applied without inflection and relieved by large areas of white. Typical among them is *The Potato* (1928, Gelman collection, New York), which is dominated by a white humanoid shape, raising an outsized hand and surrounded with fanciful, insectlike forms. Although there is a return to more strident colorism in these works, Miró brings off his complex and lively color counterpoint successfully.

A longer range effect of Surrealism on Miró was a fragmentation in his art. From the late 1920s on, painting was only one of many activities for him, activities that came to include the making of objects, sculpture, prints, and finally, ceramics and tapestry, as well as wider experimentation with materials such as sandpaper and Masonite as supports. Thus, while Miró's development up to that time can be followed with some logic, from then on the diversity of his interests makes sequential development as such largely irrelevant. One can only sample the variety of creative activity in which he is engaged at any given moment, observing how successfully he seems to realize it. On the one hand, ideas he might earlier have explored sequentially are developed side by side, with pictures of many types painted simultaneously; on the other, there are

extended periods during which he abandons a given manner, only to have it turn up again at some later date. While one can suggest the quality of his art by dipping into this maelstrom, one can only hint at its range. There can be no doubt that Surrealism's emphasis on hazard and on the creative possibilities of materials traditionally regarded as unaesthetic spoke powerfully to Miró. Having mastered the conventional painterly means he had explored for something like fifteen years, he was clearly in search of new worlds to conquer.

Surrealism seems also to have opened a way back to his Spanish roots, after years of immersion in French painting, releasing within him a sensibility more brutal and more openly powerful than that of the previous decade. His growing interest in incorporating tacks, rope, and other bold materials into his work, as well as in scumbling, scraping, and eventually burning parts of his compositions can be seen in part as a revolt against a learned (if sympathetic) tradition of artistic finesse. Surrealism thus offered Miró not a pictorial or aesthetic program but a door opening into himself, a means of nourishing part of his sensibility that must have seemed threatened with starvation by the end of the 1920s. It suggested to him that art might be made from materials not generally thought to belong to its realm, and that orthodoxy was not the only path to salvation, if salvation meant complete expression of his creative self and the achievement of aesthetic quality.

Directly relevant to Miró's interest in Surrealism is his love of poetry and the role it plays in his painting. This has two aspects: the titles he gives his pictures and the appearance of words, phrases, and even poems within pictures themselves. As to the titles—those from the late 1930s, such as "A Drop of Dew Falling from the Wing of a Bird Awakens Rosalie Asleep in the Shadow of a Cobweb" [30], are particularly evocative—there is no doubt that they and the images to which they are attached are intimately associated in Miró's mind. The association is Miró's, however, and aside from clues as to the associations that particular forms in a given painting may have for the artist, a Miró title has no more significance than the title of any other painting. That is, the character and quality of the picture are carried by its image and the title must be looked on largely as a denomination. Miró himself has stated that his titles grow with the development of the picture, and while they may result from a related creative urge, "the title is not a literal illustration of the picture, nor is the picture an illustration of the title" (Jacques Dupin).

The words and phrases within Miró's pictures bear roughly this same relationship to the compositions of which they are part. While they may have personal associations

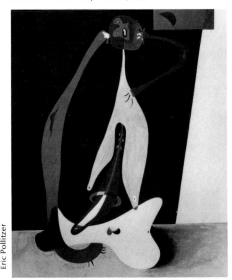

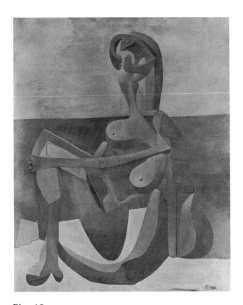

for Miró, those associations remain private to him. Their aesthetic meaning is limited to their function as pictorial elements, as Miró himself has clearly stated—"It's the plastic role of the word that interests me." Thus, the "meaning" of even as elaborate a poem as appears in *Le corps de ma brune. . .** (Hermanos collection, New York) is its pictorial function, and the importance of that meaning is the success with which the pictorial function is fulfilled. The fact that Miró is capable of distending the word *poursuit* in the picture *Un oiseau poursuit une abeille et la baisse* (Private collection, France) to suggest the motion of a bird has no more importance than that Beethoven can evoke a thunderstorm using an orchestra. The meaning and success of the one is purely pictorial, of the other purely musical. Again, one can listen with profit to Miró himself: "I have always evaluated the poetic content according to its plastic possibilities."

Miró's Surrealism of the early 1930s is heavily indebted to Picasso's work of the late '20s. A series of oils on paper produced during 1931, for example, clearly reflects sculpture studies and paintings made by Picasso from 1926 to 1928.

Picasso's sculpture studies consist of intersecting patterns of black lines punctuated with dots at the points at which they cross, while the paintings develop broad linear patterns that move freely across geometrically composed color areas to which they are not directly related. In his works on paper of this time, Miró first establishes a pattern of detached color areas, generally rectangular, then develops a broad linear pattern on top of them, with dots at intersections or at the ends of lines. While this independent motion of color and line was used by others, notably Klee, it is to Picasso that Miró seems most indebted for it. In 1932 he executed a group of small paintings on wood that also clearly refer to his compatriot. These establish clearly defined, flat color areas covering the entire surface of the board, on top of which bony configurations reminiscent of Picasso's 1928 *Design for a Monument* are developed. Among the best of these is *Seated Woman* [20, fig. 11], which clearly recalls Picasso's 1930 *Seated Bather* (fig. 12) not least in the boniness of its forms. Miró no doubt admired the restraint of Picasso's controlled and classical Surrealism—if Surrealism it was—and found it more suited to his own purposes than the more literary and fantastic creations of Dalí, Magritte, and others.

During 1933 and 1934 Miró produced a group of ambitious works that grew out of the small paintings on wood of 1932, suppressing the figuration of the latter by

**I have chosen to keep a few of Miró's more poetic titles in French, feeling that to translate them would trivialize them.*

dispersing their forms. In these canvases, most of them quite large, the flat color backgrounds of the earlier works are softened and modulated so as to become atmospheric. Mostly quite dark in tonality and very close-valued, these grounds sometimes appear monochrome but more often have clearly defined areas of different hues that shade off into one another. The forms floated on top of them are organic, often bony, and are detached from one another and sometimes voided. As in the smaller paintings, they tend to change hue where they overlap, a coloristic equivalent to the dots at the linear intersections of the 1931 oils on paper. Thus, a black form overlapping a white one may turn blue in the area of overlap. The problem for such compositions is that the pictorial pressure exerted by their powerful grounds is extremely difficult to counteract. Forms of sharply contrasting hue and value exert the most effective counterpressure. White and red shapes tend to hold the pictures together most firmly, while black, of which Miró used a good deal, works less well. The paintings with relatively fewer forms floating at some remove from one another can also be prob-lematical, as Miró himself seems to have realized by 1934, when he tended to increase the number of elements in the pictures. A work such as *Hirondelle Amour* (Museum of Modern Art, New York) is particularly successful since the cursive pattern of the words helps connect the more abstract shapes. At their best, these paintings rank among the finest in Miró's decorative style, although they are decorative with a difference. Their dark, intense—one is tempted to say brooding—colors mitigate their otherwise deco-rative character and contrast with the coloristic lyricism of the works of the mid-1920s.

In the latter half of the 1930s there is a notable return of expressionist fierceness in Miró's work. At times this takes the form of violent or threatening subject matter, at times it consists of the introduction of crude materials such as nails and rope or a preference for roughened surfaces and coarse paint application. Both these strains are represented during 1935–36, the former in a group of small works on copper or Masonite. Invariably representing grotesque and attenuated figures set in a landscape, these works play light foregrounds against very dark backgrounds that suggest night skies [see 23]. The figures themselves stand out against this darkness in modulated reds, yellows, and ochers, managing—either by the placement of their red limbs against yellow halations, or merely by their being set off against the dark ground—to give the impression that they are glowing or burning.

If the paintings on copper seem to be less restrained versions of the small figurative works on wood of 1932, a series of moderate-sized pictures on Masonite of 1936 is more directly related to the large canvases of 1933–34. The warm, mottled surface of

the Masonite gives Miró all the inflected ground he needs, and on it he floats black shapes, with occasional red or white patches, that recall those of the earlier works but are brushier and less sharply delimited [see 24]. Since the ground pressure from the Masonite is less than that from the modulated paint of 1933–34, these pictures are less daring but generally more cohesive in their achievement. Occasional areas of heavy impasto suggest crudeness in this relatively refined context and Miró seems consciously to be trying to violate anything that might be construed as beautiful in this and most of his work of the period.

The peak of this aggressive trend came in 1937–38, partly in pictures that seem scrawled and daubed rather than painted. In them, everything is done to obliterate the idea of finesse of execution, and even the colors are often crude either individually—brown or greenish brown are not uncommon—or in their juxtapositions. More important is the iconographical ferocity embodied particularly in three paintings: the gigantic *Reaper*, painted for the Spanish Pavilion of the Paris World's Fair in 1937 and since destroyed; the *Decoration of a Nursery* (1937, Weil collection, St. Louis); and the *Woman's Head* of 1938 (Minneapolis Museum of Art). In both of the latter, distorted figures, their mouths reduced to lines with predatory-looking teeth, are rendered in black inflected with red, green, and yellow against a scumbled blue ground. Whether or not Miró was responding to the threatening political climate around him, as has often been suggested, these works seem the equivalent in his oeuvre of *Guernica* in Picasso's. In both cases, the pictures are impressive insofar as one identifies with the world events apparently referred to in them, or with the emotions seemingly expressed by the figures represented. In both cases, however, the message of violence and anguish overwhelms the aesthetic vehicle in which it is embodied, undermining the works' ultimate artistic quality.

Miró's masterpiece of these years, and a picture that successfully transmutes the real emotions of other works into aesthetic terms, is the 1937 *Still Life with Old Shoe* [26]. Unique in his oeuvre both iconographically and stylistically, it represents four objects—a shoe, a bottle, a fragmentary loaf of bread, and a potato with a fork stuck into it—on a table top whose far edge makes an horizon through the center of the painting. The background is occupied by three ameboid black shapes (one of which echoes the form of the bottle) floating against, and at times interpenetrating, color areas with indistinct edges. Rendered in mixed yellows, turquoises, and purples, these areas produce an out-of-focus phosphorescence against which the foreground objects are seen. Those objects themselves are rendered in black and in more intense values of the

background colors, applied in somewhat smaller and more clearly delimited areas. The way in which the reds, blues, greens, and yellows are placed against one another—an extremely sophisticated development of the color inflections within the small objects in the paintings of the mid-1920s—results in a dematerialization of the objects they define and makes the painting seem to be glowing with a disembodied intensity that may be unique in the art of this century.

As *Still Life with Old Shoe* demonstrates, Miró is too intensely an artist to capitulate completely to such external pressures as were driving him during the late 1930s, and he continued to produce pictures of great refinement. Two of these, *Une étoile caresse le sein d'une négresse* [29] and *Self-Portrait II* [28], both of 1938, place discrete forms in various colors against flat black grounds. If the blackness of the ground was meant to embody some of the sensibility found in other works of the period, Miró's painterly talents intercepted that purpose and both pictures are not only powerful, but are statements of great beauty. The forms in each are clearly defined and carefully related one to the other, resulting in a decorative pattern of the most sophisticated sort.

A group of paintings on Celotex from 1937, notably *The Circus* [25], seems to have provided a lyrical safety valve for Miró. These hark back to the early 1930s in that their colors—in the case of *The Circus* blue (sometimes whitened), red, yellow, and green—are floated against the rough ground of the Celotex and a linear pattern is drawn on top of them, sometimes following their contours and sometimes violating them. The linear pattern draws the entire composition together, foreshadowing developments of around 1940. The first definite signs of those developments are some paintings on burlap of 1939, the heavily textured burlap providing a light-inflected ground that is more aggressive than that of the Celotex. Because the ground asserts itself so strongly, the paint placed on it is more closely identified with it, and the effect is less atmospheric than that of the earlier work. Typical of this group is *A Drop of Dew Falling from the Wing of a Bird Awakens Rosalie Asleep in the Shadow of a Cobweb* [30]. In it and the other works of its type one first sees the forms that were to predominate in Miró's work for some fifteen years and are reflected even in quite recent compositions. Dabs of paint roughly applied on the surface of the burlap are organized into patterns by a web of lines drawn across them. The shapes created at the intersections of these lines are frequently filled, often in black but sometimes in color, and the result is a closely interwoven pattern that is at once more coherent and better able to stand up to the active ground than the linear patterns in the paintings of 1933–34. The fantasy of the animalistic shapes in *A Drop of Dew . . .*, as well as the roughness of

the burlap and the unsubtle black-red color combination that dominates the picture, is married to a delicacy of line and deep feeling for all-over decorative pattern that demonstrate how Miró has increasingly been able to reconcile the two strains in his art, not synthesizing them to produce a third transmuted style, but letting them speak side by side in the same work without doing violence to either. Moreover, he finds ways to make elements of one sensibility result in effects of the other. Thus, the heavy black of *A Drop of Dew* . . . is ameliorated by the aggressive texture of the burlap it covers into a velvety softness.

By the early 1940s Miró had stopped painting altogether, and he was not to resume until the very end of the Second World War. During 1940 and 1941, however, he produced the series known as *Constellations* [see 31 and 32], executed in gouache and oil on paper, apotheosizing his concerns of the previous decade. As if to maintain his sanity in the face of world events, he turned to these small-scale compositions, the best of which, while delicate and full of fantasy, are of great pictorial strength. Miró first roughened the surface of the paper on which he worked, then covered it with washes of atmospheric color. On top of this he developed patterns of thin lines and circles and other shapes in black, blue, red, green, yellow, and sometimes white. The grounds are at their best when they are most neutral in hue—brown, for example—and are most subtly modulated. Those that are too bright in hue or too abrupt in transition interfere with the patterns on top of them. The patterns, in turn, are best when they are densest and most various. When they are sparse, the grounds tend to take over, unbalancing compositions by destroying their rhythms. Again, one sees Miró giving full reign to the expressionist aspect of his nature, in the fanciful figures and faces that constellate out of the surface patterns, side by side with its decorative aspect, seen in the subtle painterliness of the grounds and the overall decorative mastery with which he manipulates his compositions.

Since the Second World War Miró's work has continued to explore various directions, and one finds periods of two or three years during which he is prolific as a painter, then periods of equal length during which he paints almost not at all. Generally speaking, his painting has developed toward greater simplicity and larger scale, the latter perhaps encouraged by commissions he has received for sizable murals.

Beginning in 1944 Miró developed the manner for which he is now probably best known, a manner that is basically a large-scale development of the *Constellations*. An excellent example of the type is *The Harbor* of 1945 [33]. Here the ground is composed of a pale gray wash applied sufficiently thinly that the canvas shows through in many

areas, giving the effect of a subtle, yielding atmosphere. On top of this ground Miró develops a pattern of lines and shapes that seem, unlike those of the *Constellations,* to represent a single figure. This major configuration embraces well over half the canvas, and the black shape at the center is large enough to focus the entire composition. There is, thus, a certain holistic quality about the picture permitting it to be grasped almost at a glance, unlike the *Constellations,* which must be read from point to point. Although the major color is black, most often used to fill in areas created by intersecting lines, fairly flat primaries—red, blue, green, and yellow—also appear. The success of pictures such as *The Harbor* depends on very much the same factors as the success of the *Constellations* or indeed, some of the works of the mid-1920s. The grounds must be unified and carefully modulated, although they need not be as reticent as that in *The Harbor*—witness the intense blue ground of the mural painted for the Terrace Plaza Hotel in Cincinnati. More important, the drawn configurations must be bold enough, large enough in scale, and developed across enough of the surface of the picture to resist the ground pressures. Generally speaking, the more shapes are interconnected the better, and the exact relationship of filled in and colored area to line, and of areas to one another, is crucial in holding the composition together. Pictures in which forms are not sufficiently bold in scale, or in which they are too widely separated one from the other, disintegrate from lack of coherence. Miró continued to develop compositions in this manner through the early 1950s. As they developed they became increasingly free, and more and more one sees unbounded areas of paint, as in *Woman and Little Girl in Front of the Sun* [34], or roughened and scumbled color areas modulating between the ground and the pattern drawn on it, as in *Painting* [35].

At the same time as he continued to work in this *Constellation*-related manner, Miró developed another strain in his painting, one that became most obvious beginning about 1949. In it, line is thickened and roughened to the point at which it becomes calligraphic shape. No longer uniquely black, lines may be rendered in color or surrounded with circles, stars, or other elements that are also tinted. Occasionally black shapes are surrounded with colored halations or the ground color is modified immediately behind them. This gives a curious atmospheric effect not unlike the phosphorescence of the *Still Life with Old Shoe,* but employed more abstractly. In other pictures, enlarged shapes are rendered flat against a flat ground, and from time to time light shapes are presented against dark grounds. Some of these compositions are extremely bold, and in the absence of such relieving delicacy as may be provided by a fine linear pattern they can tend toward stridency and vulgarity. Miró uses dotted

patterns to mitigate the heaviness of some of the canvases, but even these are not always successful and the effect can be overburdened.

Although Miró ceased to paint for the last years of the 1950s, he began to be particularly prolific again in 1960 and there emerged from his studio works of startling simplicity and novelty, whose principal pictorial referents are his own pictures of 1924–27. *The Red Disk* of 1960 [37] represents the expressionist side of this development, and one cannot but imagine that it is heavily under the influence of Abstract Expressionism. A huge off-white splatter, dense toward its center but dripped and splashed at its periphery, all but covers a black ground. An intense red eccentric circle is placed to the right of center, and the white area is further relieved by small patches of yellow and other colors, as well as by fine black drawn "Miróisms." Although bold in its forms and conceived and executed on a large scale, the picture depends for its success on considerable coloristic subtlety. The fact, for instance, that the splash is an off-white softens it, allowing it to modulate between the red circle and the black ground, relieving the heaviness that might result from their immediate juxtaposition and unifying the entire composition.

More surprising still are the three huge canvases known as *Blue I, II,* and *III,* executed in 1961. These pictures consist of rich, modulated blue grounds on top of which are placed the fewest possible black and red elements. The sparest of them, *Blue III* (Pierre Matisse Gallery, New York), leaves almost the entire ground bare to speak for itself, while in the most powerful, *Blue II* [38], a series of irregular black circles entering the canvas midway along its right edge is brought to an emphatic halt by a vertical red accent near the left side. The authority, austerity, and decorative scope of these pictures apotheosizes the reductivist trend first fully apparent in 1927. The extremity of that trend is represented by the huge triptych, painted in 1968, known as *Mural Painting for the Cell of a Solitary Man* (Fundació Joan Miró, Barcelona). Each canvas consists of the finest of black lines wending its irregular way across a canvas of the starkest white. Miró tried many variations on such reductivism during the 1960s. In one of the most successful, *The Flight of the Dragonfly before the Sun* (Mellon Collection, Upperville, Virginia), also of 1968, a huge red circular shape dominates the center of a canvas brushed out to its edges with an inflected blue, while the upper right corner holds a small black circle and a short black line. To relieve the pictorial intensity Miró has left white halos around the red and black elements. (A related, more complex, composition also of great presence is the 1972 *Toward the Escape* [43].) Another picture of 1968, *The Passage of the Migratory Bird* (Pierre Matisse Gallery, New York), relieves its

blue ground with the shortest of black lines embedded in an irregular white oval at the upper right. Still other compositions scatter stenciled letters and numbers across washy, open grounds of two or three hues.

At the same time he was producing these daring compositions, Miró continued to enlarge the scale of the pictures dominated by black linear patterns. As the patterns thickened, the areas they enclosed became increasingly coruscated and obviously applied, the color more intense. Working with ideas first developed in his postwar pictures, Miró created series of connected and bounded shapes across monochrome grounds, but since the shapes tended to be entirely filled in with high-valued color, the paintings sometimes strangled pictorially for lack of air. When the opaque shapes of such pictures were placed before atmospheric grounds, however, as in *Woman before an Eclipse with Her Hair Disheveled by the Wind* [40], they could succeed majestically. During the 1960s and '70s Miró has increasingly permitted his canvases to be taken over by large areas of matte black [see 45]. These areas occasionally take on the shapes of predatory creatures, but most often are used simply for their pictorial value. They are of such power as to be extremely difficult to relieve, and when they occupy almost the entire surface of the canvas, they risk making the composition inert. When they are relieved with white or other colors, however, or are dispersed across the canvas, they can be made to function effectively.

During the mid-1970s Miró has also experimented with controlled burning of his canvases, integrating the shapes thus created with those on the remaining painted surface. Daring as the idea of burning may seem, the reality is problematical, allowing the artist insufficient control over the aesthetic result, which changes with each surface against which the picture is shown. Generally speaking, one feels the physical presence of paint—which is broadly spattered, splashed, or roughly applied—more in Miró's work of the late 1960s and '70s than in any of his previous efforts. Moreover, he has brought to his cruder expressionist manner the large scale formerly reserved for his decorations. In all of this one senses a powerful drive, all the more remarkable in a man in his seventies, to give scope not only to his paintings but to every facet of his creative personality. That drive is characterized by the extraordinary willingness to experiment and receptiveness to new ideas that have informed Miró's art from the beginning.

It has not been uncommon recently for critics of Miró's work to say that the postwar years, particularly the last two decades, have seen a qualitative falling off in that work and that one must look to the early Miró for major achievement. No doubt this is due in part to the range of Miró's efforts during this period, efforts, it must be admitted, not

always of consistent quality. This range has distracted attention from his painting and from the level that painting has been able to maintain. Moreover, the dissemination of Miró's efforts through prints, both those of his own devising and those produced commercially, has resulted in a familiarity that has bred not a little contempt. But the real villain is probably insufficient editing. It is not uncommon for an older artist to be more lenient with the number and character of works he lets out into the world than a younger one, and one suspects that Miró has permitted himself this indulgence. Editing becomes all the more necessary to a man whose age dictates the conservation of his energies, permitting him the intensity characteristic of first-rate art in relatively fewer works. Despite all this, the fact is that Miró continues to paint works equal to, indeed often surpassing, any he has ever produced. If that fact is temporarily obscured by other circumstances, it will, in the long run, become triumphantly apparent.

If one hallmark of aesthetic development during the last century has been experiment of the most diverse kind, leading to the incorporation into art of both materials and effects not previously thought to belong to it, Miró is a very microcosm of that development. Protean in his interests and production, his openness to every visual form and effect exemplifies the richness of the creative soil from which his work springs. If not all of his experiments have succeeded, the failures have at least enriched that soil, assisting the growth and flowering of the successes. By now it is clear that, with Matisse and Picasso, Miró is one of the three giants of European modernism in this century, and, indeed, his achievement may be even more sustained and more varied than that of his compatriot. That achievement, forged entirely in its own terms, shares both Matisse's French fluency and Picasso's Spanish expressionism, and stands easily alongside the best of both.

MIRÓ AND THE UNITED STATES

Judi Freeman

Perhaps no twentieth-century European painter has received greater acclaim in the United States than Joan Miró. Americans were among his most ardent supporters during his early years in Paris, and American private collectors, museums, and galleries have continued to purchase and exhibit his work throughout the last half-century.

Recognition of Miró's talent came slowly, with much of his early commercial and critical success resulting from the enthusiasm of American expatriates living in Paris, most notably Ernest Hemingway. Aided by the poet Evan Shipman and the writer John Dos Passos, Hemingway bought *The Farm* [9] in 1925 for five thousand francs, which he claimed that he and his friends had collected in local bars and cafés. He later wrote that *The Farm* "has in it all that you feel about Spain when you are there and all that you feel when you are away and you cannot go there."[1] Hemingway's acquisition of *The Farm* marked the beginning of a lasting friendship with Miró, which was subsequently commemorated in *Death in the Afternoon*:

. . . sitting in the heavy twilight at Miró's; vines as far as you can see, cut by hedges and the road; the railroad and the sea with pebbly beach and tall papyrus grass. There were earthen jars for the different years of wine, twelve feet high, set side by side in a dark room; a tower on the house to climb to in the evening to see the vines, the villages and the mountains and to listen and hear how quiet it was. In front of the barn a woman held a duck whose throat she had cut and stroked him gently while a little girl held up a cup to catch the blood for making gravy. The duck seemed very contented and when they put him down (the blood all in the cup) he waddled twice and found that he was dead. We ate him later, stuffed and roasted; and many other dishes, with the wine of that year before and the great year four years before that and other years that I lost track of while the long arms of a mechanical fly chaser that wound by clock work went round and round and we talked French. We all knew Spanish better.[2]

News of Miró's activities in France rapidly crossed the Atlantic. At a time when his work was attracting little notice in the French press, it was featured in a 1926 issue of the New York-based *Little Review*. The first of Miró's paintings to come to this continent, *Le renversement*, 1924 (*The Somersault*, Yale University Art Gallery, New Haven), was acquired by Marcel Duchamp's and Katherine S. Dreier's Société Anonyme and prominently displayed in their 1926 *International Exhibition of Modern Art* at the Brooklyn Museum. Miró's inclusion in this exhibition, along with other artists

associated with the growing Surrealist circle in France, received considerable attention in this country. American collectors and dealers traveled to Paris in increasing numbers to view paintings by the Surrealists, especially Miró's work, which had been given particular emphasis by several American critics. Henry McBride declared in his column in *The Dial* of 1928:

No other name, during the winter, had come across the seas with such insistence, and nothing came across with the name—no pictures. If he really were worth bothering about, it would be necessary, it seemed, to make another of those fatiguing trips to Paris in order to do it there. A traversée "was clearly indicated," as the fortune tellers say, and so, being essentially dutiful, I went.[3]

One particular painting, *Dog Barking at the Moon* [15], caught McBride's attention and was purchased for the Gallery of Living Art in New York, which he had founded with A. E. Gallatin. Exhibited in 1929, first in the Museum of Modern Art's temporary exhibition space at 680 Fifth Avenue and then at the Brummer Gallery on Fifty-seventh Street, it was initially ridiculed by the press, as was Miró's first U.S. solo show, at the Valentine Gallery in New York. Lloyd Goodrich, reviewing the latter in 1930, observed that Miró's "is a gay and ingenious talent, but scarcely a profound one" and compared his work to the popular comic strip Krazy Kat.[4] More positive appraisals of Miró's work, however, were also starting to appear in reviews by American critics in the early 1930s. An *Art News* reviewer declared that one of Miró's solo shows was not "to be missed by any gallery-goer with any relish for the drift of modern art. Miró is the *enfant terrible* of the moment and should be seen."[5]

Although Miró subsequently disassociated himself from the Surrealists, it was his participation in their exhibitions and activities during the mid- and late 1920s that had sparked American interest in his work, and he continued to be linked with Surrealism throughout the 1930s. The galleries that featured his painting were those that tended to favor artists from the Surrealist circle. Miró's 1930 solo show at the Valentine Gallery followed an exhibition there of paintings by Giorgio de Chirico, considered the chief precursor of the Surrealist movement. Two months later Miró had a solo show at the Arts Club of Chicago, which again followed exhibitions of Surrealist art. His paintings were also featured in the 1931 *Newer Super-Realism* exhibition at the Wadsworth Atheneum in Hartford and in the 1936 *Fantastic Art, Dada, Surrealism,* organized by Alfred H. Barr, Jr., at the Museum of Modern Art. At the same time Miró, more than other Surrealist artists, was being given solo exhibitions—in New York, Chicago, San

Francisco, Los Angeles, Hollywood, and Honolulu. This increasing prominence stimulated both museums and private collectors to acquire his work. Pierre Matisse became his dealer in 1932 and has held regular exhibitions of his work ever since. Several of the gallery's patrons—including Walter R. Chrysler, Saidie A. May, and A. E. Gallatin—belonged to the growing circle of individuals who were developing significant private collections of Miró's work. The director of the Wadsworth Atheneum, A. Everett ("Chick") Austin, Jr., who was an early supporter of Surrealism in this country, bought several of Miró's paintings for the museum, and the Museum of Modern Art acquired a number of them from its Surrealist-related shows.

Miró's popularity in the U.S. intensified during World War II. His first major museum retrospective, at the Museum of Modern Art in 1941, was a huge success. The first monograph on the artist in any language, written by James Johnson Sweeney, appeared with the exhibition and confirmed Miró's independence from the Surrealists. Miró's most important work of the war years—the *Constellation* series—also contributed to his American reputation. He had begun the *Constellations* in 1940 at the home of the American architect Paul Nelson in Normandy, and they were the only possessions he carried with him when the war forced him to flee from France to Spain. All but one of the twenty-three *Constellations* were sent to the Museum of Modern Art via diplomatic pouch.[6] The museum passed them on to Pierre Matisse, who exhibited the series in 1945. Every work in the exhibition was sold, and most still remain in American collections. One result of this continued attention was a commission to paint a mural for the restaurant at the Terrace Plaza Hotel in Cincinnati. To fulfill the commission, Miró came to the United States for the first time in 1947, staying in the New York studio of painter Carl Holty, whom he had previously met in Paris. He worked on the mural there from February until October.

America's "force and vitality" made a strong impression on Miró, and he commented that "to me the real skyscrapers express force as do the pyramids in Egypt."[7] With the writer Ruthven Todd, he rode on the New York subway from 14th Street to 125th Street, a ride that Todd recalled several years later:

. . . it shook, rattled and banged as if its behavior could persuade the passengers that they were travelling at a much greater speed than actually they were doing. Miró suffered the noisy and uncomfortable ride in compulsory silence. As we climbed the stairs to the exit on 125th Street, he turned a serious face toward me. "We go back on the autobus, yes, Todd?" he asked anxiously.[8]

Miró maintained an active schedule and consequently absorbed varied aspects of American culture. His longtime friend and collector, Josep Lluis Sert, the Spanish architect he had met in Paris in the late 1920s, entertained Miró and his family at his home on Long Island. Sert recently recounted some of Miró's reactions to American life:

I remember his impressions and excitement with such things as Times Square, and his enthusiasm with the "youthful" side of this country, such as the games, circus and other events at Madison Square Garden. The Chinese Theatre in Chinatown was also a special event for Miró, and we visited it often. We were often in the company of mutual friends like Fernand Léger, Marcel Duchamps, Alexander Calder and his family who we saw frequently in Roxbury; and we also saw James Johnson Sweeney and his wife Laura.[9]

American art was of particular interest to Miró. In an interview during the trip, he observed, "I admire the American painters greatly. I especially like their enthusiasm and freshness. This I find inspiring. They would do well to free themselves from Europe's influence."[10] Miró had previously made etchings and drypoints at Stanley William Hayter's Atelier 17 in Paris, and while in New York he produced several etchings in Hayter's American studio.[11] Among the various artists he met there were Arshile Gorky and his wife, who entertained Miró at their Union Square studio. One of their guests that evening, Ethel Schwabacher, recorded the spirited exchange that took place:

After supper we sat about the enormous low table. Gorky offered wine in a bottle and without glasses. With reversed hand and arm bent sharply at the elbow he raised the flask to his lips, and tilting his head back, drank deeply from the curved spout. Then he passed the flask. No one could manage it, the wine spilled, faces were dripping, laughter mixed with the wine. Gaily Miró took the flask, sat straight, his legs firmly planted wide apart, then with gesture of bravado and virtuosity, accomplished the feat. Waves of applause greeted him. Now there were requests for song. Gorky sang the wailing trills and arpeggios of the East, songs of Armenia and Georgian Russia, and Miró countered with Catalan songs, close in spirit, high-keyed, ringing, intensely melancholy.[12]

Miró reflected in an interview on the tiring pace of his days in New York:

Well here in New York I cannot live the life I want to. There are too many appoint-

ments, too many people to see, and with so much going on I become too tired to paint. . . . I absolutely detest openings and nearly all the parties. They are commercial, "political," and everyone talks so much. They give me the "willies". . . . The sports! I have a passion for baseball. Especially the night games. I go to them as often as I can. Equally with baseball, I am mad about hockey—ice hockey. I went to all the games I could. . . .[13]

Miró returned to Spain with one tangible souvenir of the United States: a collection of American sidewalk toys.

Miró did not visit the United States again until May 1959, twelve years after his first trip. In the intervening years, several important collections of his work had been formed. G. David Thompson, Mr. and Mrs. James W. Alsdorf, Morton Newman, and Larry Aldrich, to name just a few, had amassed sizable collections representing all periods of Miró's painting. This increased collecting of his work, in addition to continual exhibitions at galleries in many American cities (notably the Perls Galleries in New York), unquestionably provided the impetus for the Museum of Modern Art's second retrospective of Miró's work, which prompted his 1959 trip. He also visited Cambridge to see his friend Sert, who had succeeded Walter Gropius as dean of Harvard's School of Architecture. In 1950, at the urging of Gropius, Miró had been commissioned to paint a mural for Harkness Commons in Harvard's Graduate Center. Nine years after the mural was installed, a ceramic version by Miró and the ceramist Josep Llorens Artigas replaced the original canvas, which was given to the Museum of Modern Art. In 1959 Miró also traveled to Washington, D.C., to be presented the $10,000 Guggenheim International Award—for his 1958 murals of *Night* and *Day* for the UNESCO Building in Paris—by President Eisenhower, who showed Miró one of his own paintings, a mountain scene.[14] When asked during this trip about what he found most interesting in America, he responded: "The young people. You feel it, you sense it, a breaking-through, interest, excitement, activity in art. It is in Spain with the younger generation, too. After the war, for a while, they seemed completely flat. Now they are alert and alive, though with less freedom of expression there than here."[15]

Miró's ties to America became more evident in his art at the beginning of the 1960s. In 1961 he painted three monumental canvases: *Blue I* (Galerie Maeght, Paris), *Blue II* [38], and *Blue III* (Pierre Matisse Gallery, New York). The paintings marked a return to his style of the 1920s, a revival that was probably inspired by his exposure to American abstract painting. His closeness to this country clearly grew stronger in this decade; he returned to the United States three times. At the time of his trip in 1961, approximately

half of his paintings were in American collections.[16] During this visit, he stayed with Sert and completed a mural for his Cambridge home. He also traveled to New York in conjunction with the exhibition of recent paintings and ceramics that introduced his *Blue* series at the Pierre Matisse Gallery.

Since his last visit here in 1968, to receive an honorary degree from Harvard, Miró has undertaken several U.S. commissions, including a mural for the Ulrich Museum of Art at Wichita State University in Kansas; an outdoor sculpture for Chicago; tapestries for the World Trade Center, New York; and, most recently, a tapestry for the East Building of the National Gallery of Art. He has been honored with numerous exhibitions at major museums across the nation and has been given frequent one-man shows at Pierre Matisse and other galleries.

Miró's link with this country has remained strong and constant. His painting exerted a profound influence on the Abstract Expressionists, particularly Gorky and Pollock, and, in turn, his work was stimulated by their innovations. Americans have collected his work with undiminished devotion since the early 1930s. A substantial portion of his painting from the 1910s and 1920s is owned by American collectors and some of the finest painted works from his subsequent years figure prominently in American collections. His vast production of lithographs has made acquisition of his work possible for an increased number of Americans and has permitted greater exposure to his work. Although Miró enjoys wide recognition from Japan to his native Catalonia, his reception has been, perhaps, greatest of all in the United States.

Notes

1. Ernest Hemingway, "The Farm," *Cahiers d'art,* nos. 1–4 (1934): 28.

2. Ernest Hemingway, *Death in the Afternoon* (New York and London: Charles Scribner's Sons, 1953), pp. 449–50.

3. Henry McBride, "Modern Art," *The Dial* 85, no. 6 (December 1928): 526.

4. Lloyd Goodrich, "November Exhibitions," *Arts Magazine* 17 (November 1930): 119. See also, "Miró's Dog Barks While McBride Bites," *Art Digest* 4 (December 15, 1929): 5ff.

5. "Miró Exhibition: Valentine Gallery," *Art News* 29 (October 25, 1930): 11.

6. Interview with Pierre Matisse, New York, May 25, 1979.

7. Francis Lee, "Interview with Miró," *Possibilities,* no. 1 (Winter 1947–48): 67.

8. Ruthven Todd, "Miró in New York: A Reminiscence," *The Malahat Review* 1 (January 1967): 80–81.

9. Letter to the author from Josep Lluis Sert, July 12, 1979.

10. Lee, "Interview," p. 67.

11. Joann Moser, *Atelier 17,* exhibition catalog (Madison, Wisc.: Elvehjem Art Center, University of Wisconsin at Madison, 1977), p. 31.

12. Ethel K. Schwabacher, *Arshile Gorky* (New York: Macmillan for the Whitney Museum of American Art, 1957), pp. 122–23.

13. Lee, "Interview," p. 66.

14. Miró praised the painting as "very poetic and sensitive." "President Eisenhower Presents Award to Miró, Spanish Artist," *New York Times,* May 19, 1959, p. 15.

15. Aline B. Saarinen, "A Talk with Miró about His Art," *New York Times,* May 24, 1959, p. 17.

16. Jacques Dupin, *Joan Miró: Life and Work* (New York: Abrams, 1962), *passim.*

CHRONOLOGY

Judi Freeman

1893	April 20—Joan Miró born to Michel Miró Adzerias, a goldsmith, and Dolores Ferra, pasaje del Credito, 4, Barcelona.
1900	Attends school in the calle Ragomir, Barcelona. In evenings, takes drawing lessons with Sr. Civil.
1905	Fills sketchbooks, chiefly with drawings of nature, during visits to his maternal grandparents in Tarragona and Palma de Majorca.
1907	Studies business at a Barcelona school for a brief period. Subsequently attends Escuela Oficial de Bellas Artes de la Lonja in Barcelona and is influenced by two teachers, Modesto Urgell and José Pascó.
1910	Abandons art studies and takes job as clerk with a Barcelona business.
1911	Contracts typhoid fever. Convalesces at his parents' home in Montroig, a town outside Barcelona.
1912	Enrolls in Francesco Galí's Escola d'Art in Barcelona. Sketches street scenes, the harbor, the circus, and cabarets. Meets the painter E. C. Ricart and the ceramist Josep Llorens Artigas. Sees Impressionist, Fauve, and Cubist paintings for the first time at the Galerie Dalmau, Barcelona. Makes first oil paintings.
1915	Graduates from Galí's school. With Ricart, shares first studio, at Baja San Pedro, 51, Barcelona. Participates in drawing sessions with members of the Sant Lluch circle, a group the architect Antonio Gaudí had belonged to in previous years. Meets Joan Prats and J. F. Rafols. Begins to paint in a Fauve style and to draw nudes.
1916	Continues to paint still lifes and landscapes. Paints his first self-portrait. The Barcelona dealer Josep Dalmau sees and commends his first canvases. Sees Ambroise Vollard's exhibition of French art in Barcelona. Reads avant-garde magazines, including *Soirées de Paris* and *Nord-Sud* and poetry by Stéphane Mallarmé, Guillaume Apollinaire, and Pierre Reverdy.
1917	Meets Francis Picabia, who is exhibiting in Barcelona and publishing *391*, a Dada review. Produces portraits and landscapes of Ciurana and Prades.
1918	February–March—first solo show, at the Galerie Dalmau, of sixty-four canvases and many drawings from 1914 to 1917. Joins Agrupació Courbet, a group of young artists associated with Artigas.
1919	Exhibits at the municipal exhibition in Barcelona with other members of the Courbet group. March–June—takes first trip to Paris, where he meets Picasso and Maurice Raynal and visits the Louvre. Produces poster for the French magazine *L'instant.* After 1919 spends winters in Paris and summers in Montroig (until 1933).
1920	Meets Reverdy, Tristan Tzara, and Max Jacob in Paris. Participates in Dada festival at the Salle Gaveau. By year's end has a studio at 45, rue Blomet.
1921	Spring—temporarily moves to a furnished room on the rue Berthollet. Begins *The Farm*

[9] (completed 1922). April–May—first solo show in Paris, at the Galerie La Licorne, organized by Dalmau, with a catalog preface by Raynal. Exhibition is a commercial and critical failure.

1922 Returns to studio on the rue Blomet and discovers that André Masson has a studio in the same building. Visited by Léonce Rosenberg, Daniel Henry Kahnweiler, Jacques Doucet, Pierre Loeb, and Jacques Viot.

1923 Fall—exhibits with other Catalan painters at the *Salon d'Automne* in Paris. Develops friendships with Jacques Prévert, Ernest Hemingway, and Henry Miller.

1924 Joins André Breton, Louis Aragon, and Paul Eluard in Surrealist group.

1925 Begins "dream paintings" and "painting-poems." June—solo show at Pierre Loeb's Galerie Pierre in Paris, organized by Viot. Exhibition stimulates widespread critical interest in Miró's work. Hemingway buys *The Farm* [9]. November—participates in first Surrealist group show at the Galerie Pierre.

1926 Collaborates with Max Ernst on sets for *Roméo et Juliette* for Serge Diaghilev's Ballets Russes. Criticized, with Ernst, by other Surrealists, especially Aragon and Breton. November–January 1927—*Le renversement* (The Somersault, Yale University Art Gallery, New Haven) acquired by Marcel Duchamp's and Katherine S. Dreier's Société Anonyme and featured in their *International Exhibition of Modern Art* at the Brooklyn Museum (the first public showing of Miró's work in the U.S.).

1927 Spring—moves to studio on the rue Tourlaque in Montmartre, where his neighbors are Ernst, Eluard, Jean Arp, and René Magritte.

1928 Spring—visits Holland. Returns to Paris and paints Dutch interiors after postcards of old Dutch masters. May—large solo show at the Galerie Georges Bernheim, organized by Loeb. Makes first *papiers collés*. Meets Alexander Calder and attends a performance of Calder's *Circus*.

1929 Paints imaginary portraits after old masters. October 12—marries his cousin, Pilar Juncosa, in Palma. Lives in Paris at 3, rue François Mouthon.

1930 May—*Papiers collés* included in exhibition at the Galerie Pierre with work by Braque, Picasso, Ernst, Arp, Duchamp, and Picabia. Makes first lithographs, to illustrate Tzara's collection of poems, *L'arbre des voyageurs*. October–November—first solo show in the U.S., at the Valentine Gallery in New York.

1931 January–February—solo show of paintings from 1926 to 1929 at the Arts Club of Chicago. July 17—daughter Dolores born in Barcelona. December—solo show of sculpture-objects at the Galerie Pierre.

1932 Creates sets, costumes, curtains, and "toys" for the ballet *Jeux d'enfants*, choreographed by Massine with music by Bizet, for the Ballets Russes de Monte-Carlo. November—first solo show at the Pierre Matisse Gallery in New York. Matisse becomes his American dealer. Returns to Barcelona (remains there until 1936).

1933	Makes first etchings as illustrations for Georges Hugnet's poem, *Enfances*. March–June—paints eighteen large canvases after collages. July—first solo show in London, at the Mayor Gallery.
1934	Begins "savage" period, making large pastels, then paintings on sandpaper. Produces several tapestry cartoons commissioned by Marie Cuttoli. Subject of a special volume of *Cahiers d'art*.
1935	May—included in Surrealist exhibition at the Gaceta de Arte, Tenerife, Canary Islands.
1936	Included in the exhibition of contemporary Spanish painters at the Jeu de Paume, Paris. Summer—goes to Montroig and makes paintings on Masonite. Returns to Paris (remains there until 1940). Included in the Museum of Modern Art's *Cubism and Abstract Art* (March–April) and *Fantastic Art, Dada, Surrealism* (December–January 1937) exhibitions.
1937	Lives in a hotel on the rue Jules Chaplain. Later moves to an apartment on the boulevard Blanqui. Attends classes, drawing from nude models, at the Grande Chaumière. Paints *The Reaper* (now lost) for the Spanish Pavilion at the Paris World's Fair. Draws poster *Aidez l'Espagne* for the Spanish Loyalists.
1938	Writes "Je rêve d'un grand atelier" ("I Dream of a Large Studio") for *XXe siècle*. Makes engravings and drypoints in Louis Marcoussis's studio. Spends summer at Varengeville-sur-Mer in Normandy with his friend the American architect Paul Nelson.
1939	Summer—lives in Varengeville; paints on burlap.
1940	Begins series of twenty-three *Constellations* at Varengeville during the first months of World War II. May 20—returns to Paris. Subsequently returns to Spain, finally settling in Palma.
1941	Completes *Constellations* in Palma and Montroig and sends them to New York. November–January 1942—major retrospective at the Museum of Modern Art and concurrent publication of the first monograph on the artist, by James Johnson Sweeney.
1942	Returns to Barcelona, living on the pasaje del Credito. Executes works on paper depicting women, stars, and birds (through 1944).
1944	*Barcelona* series of fifty lithographs appears. Makes first ceramics, with assistance of Artigas.
1945	February—solo show of *Constellations* and ceramics at the Pierre Matisse Gallery. Makes series of large paintings on white and black grounds.
1946	Paints series of women and birds in the night. Ends association with the Galerie Pierre, Paris.
1947	February–October—makes first visit to the U.S., to paint a mural commissioned for the Terrace Plaza Hotel in Cincinnati. Lives and works in the painter Carl Holty's studio, on East 119th Street, New York. Makes several etchings, including illustrations for Tzara's

©Arnold Newman

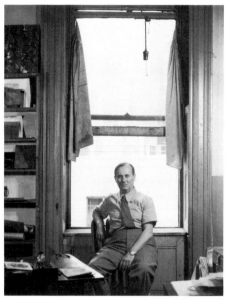

©Arnold Newman

collection of poetry and prose, *L'antitête,* at Atelier 17 in New York. May–June—solo show at the Pierre Matisse Gallery. Meets Adolph Gottlieb.

1948 March–April—Cincinnati mural exhibited at the Museum of Modern Art. Returns to Paris after an eight-year absence. November–December—first solo show at the Galerie Maeght in Paris, which leads to gallery's representing him (to the present). Monograph by Clement Greenberg published.

1949 Retrospectives at the Kunsthalle, Bern (April–May), and the Kunsthalle, Basel (June–July).

1950 Moves from the pasaje del Credito to the calle Fulgaros in Barcelona. Paints mural for the cafeteria in Harkness Commons at the Graduate Center, Harvard University. Sees exhibition of work by Jackson Pollock at Galerie Facchetti, Paris.

1953 Exhibitions celebrating his sixtieth birthday at Galerie Maeght (June–August), Pierre Matisse Gallery (November–December), and Kunsthalle, Bern.

1954 Wins Grand Prix International for graphic work at XXVIIe Venice Biennale. Stops painting until 1959, with the exception of twelve small paintings on cardboard done in 1955.

1956 Again moves studio and family from Barcelona to Palma, where he occupies a large modern studio designed by his longtime friend, Josep Lluis Sert. Major retrospective at the Palais des Beaux-Arts, Brussels (tour: Stedelijk Museum, Amsterdam, January–February, and Kunsthalle, Basel, March–April).

1957 Works on two ceramic murals, *Day* and *Night,* for the UNESCO building in Paris (completed 1958).

45 1958 October 17—UNESCO walls win Guggenheim International Award.

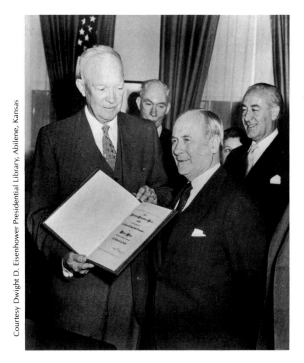

Miró receiving the Guggenheim International Award from President Eisenhower, 1959

1959 May—makes second trip to the U.S., in connection with retrospective at the Museum of Modern Art (March–May). Receives Guggenheim International Award from President Eisenhower at White House ceremony. Pierre Matisse Gallery publishes an album of reproductions of *Constellations,* with texts and preface by André Breton.

1961 November–December—makes third visit to the U.S., staying in New York.

1962 June–November—large retrospective at the Musée National d'Art Moderne in Paris. Produces series of paintings on cardboard. September–October—exhibition of 250 engravings at the National Museum of Western Art in Tokyo.

1963 August–September—major retrospective at the Tate Gallery, London. Makes large ceramic sculptures with Artigas.

1964 July—opening of the Fondation Maeght in Saint-Paul-de-Vence, designed by Sert and featuring a labyrinth decorated with large sculptures and ceramics by Miró. Participates in *Documenta III* in Kassel. Designs ceramic mural for the Graduate School of Economics, Business, and Public Administration, University of St. Gallen, Switzerland.

1965 October–November—makes fourth visit to the U.S., primarily visiting New York and friends nearby.

1966 With Artigas, executes a large ceramic sculpture called *Cathedral*, which is installed (July) in an underwater grotto off the coast of Juan-les-Pins, France. Fall—visits Japan; paints mural for a temporary space in Osaka. September–October—retrospective of graphic work at the Philadelphia Museum of Art. Begins work on an 8-by-9 foot

ceramic mural, *Alicia*, commissioned by the Solomon R. Guggenheim Museum in memory of Alicia Patterson Guggenheim.

1967 March—Guggenheim mural installed. October—wins Carnegie Institute prize for painting.

1968 May—makes fifth visit to the U.S., to receive honorary Doctor of Arts degree from Harvard University. July–September—retrospective at the Fondation Maeght, Saint-Paul-de-Vence, later traveling to Barcelona, honoring his seventy-fifth birthday. "Miró Year" celebrated in Barcelona, including exhibition at the Hospital de la Santa Cruz (November–January 1969), the first Miró exhibition held in Barcelona in fifty years.

1969 Spring—major retrospective at the Haus der Kunst, Munich. *Miró otro* exhibition organized by a group of young architects from Barcelona.

1970 With Artigas, creates large ceramic mural for Barcelona's airport. March—Miró's largest ceramic mural to date, *Impromptu*, exhibited at the Japan Gas Association's pavilion at Expo '70 in Osaka. December 18—with Antoni Tàpies, participates in sit-in of Catalan intellectuals at the monastery of Montserrat to protest the Burgos trial of young Basque nationalists.

1971 October–November—exhibition of sculpture at the Walker Art Center, Minneapolis (tours to Cleveland Museum of Art and Art Institute of Chicago).

1972 Establishment of the Fundació Joan Miró, Centre d'Estudis d'Art Contemporani, Barcelona. October–January 1973—*Joan Miró: Magnetic Fields* exhibition appears at the Guggenheim Museum. Commissioned to do tapestry for the East Building of the National Gallery of Art, Washington, D.C.

1973 April–June—large exhibition at the Fondation Maeght in honor of Miró's eightieth birthday. October–January 1974—major exhibition at the Museum of Modern Art of their forty-four works by Miró.

1974 May–October—concurrent Miró exhibitions in Paris of paintings, sculpture, and ceramics at the Grand Palais and graphic oeuvre at the Musée d'Art Moderne.

1975 June 19—opening of the Fundació Joan Miró, Centre d'Estudis d'Art Contemporani, Parc de Montjuic, Barcelona, in a building designed by Sert.

1976 June 18—formal inauguration of the Fundació Joan Miró with exhibition of 475 drawings from 1901 to 1975, selected from 5,000 drawings donated by the artist to the foundation.

1978 August–October—painting retrospective held at the Museo Español de Arte Contemporanea, Madrid.

1979 July—major retrospective in honor of his eighty-sixth birthday at the Fondation Maeght. Unveils his first stained-glass windows, which are installed in the Fundació Joan Miró.

CATALOG OF THE EXHIBITION

Works are arranged chronologically. Dimensions, as supplied by lenders, are given in centimeters (and inches), height preceding width. An asterisk by a catalog number indicates that the work will be exhibited in Washington, D.C., only.

The titles of Miró's paintings, many of them poetic, are generally in French. These have been translated here for purposes of consistency and intelligibility to an American audience.

1. **Landscape, Montroig,** 1914
 Oil on paperboard, 37 x 45 (14⅝ x 17¾)
 Pierre Matisse Gallery, New York

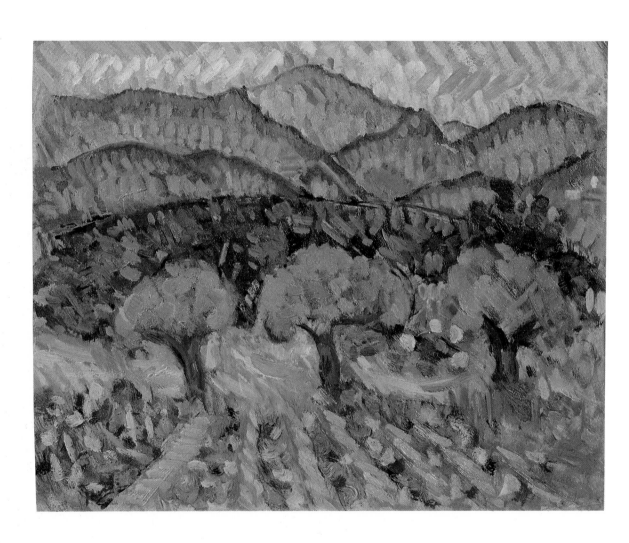

*2. **The Bottle and the Pepper,** 1915
 Oil on paperboard, 48.3 x 55.9 (19 x 22)
 Fogg Art Museum, Harvard University, Cambridge, Massachusetts
 Gift of Mr. and Mrs. Josep Lluis Sert

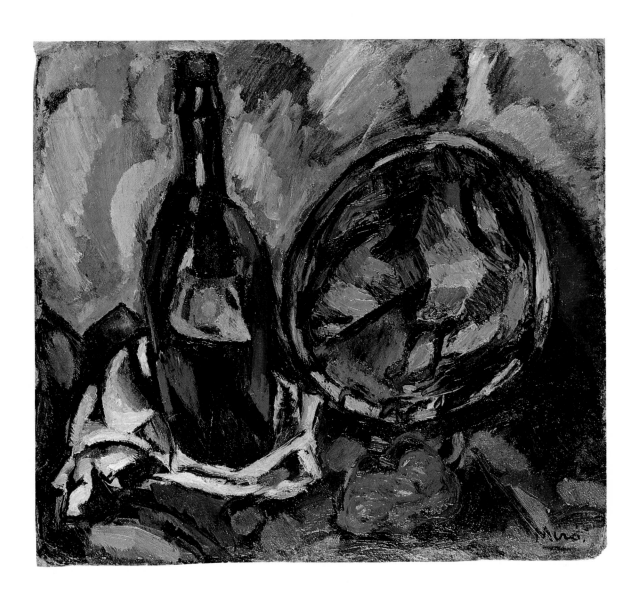

3. **Newspaper and Flower Vase,** 1916–17
Oil on canvas, 72.4 x 61 (28½ x 24)
Mr. and Mrs. James W. Alsdorf, Chicago

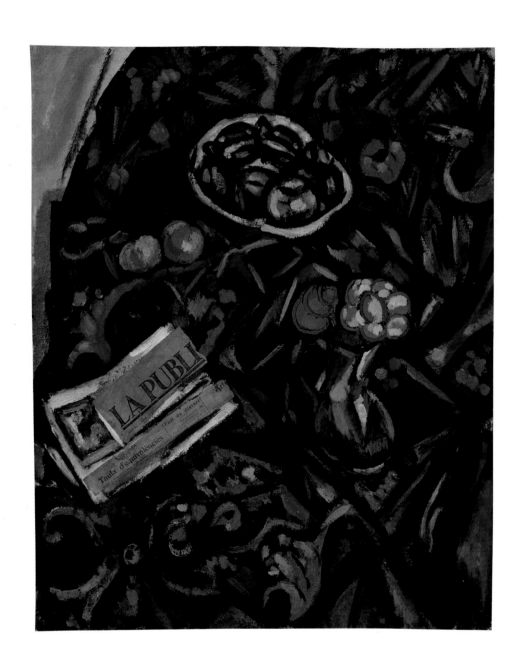

*4. **The Village, Prades,** 1917
 Oil on canvas, 65 x 72.6 (25⅝ x 28⅝)
 The Solomon R. Guggenheim Museum, New York

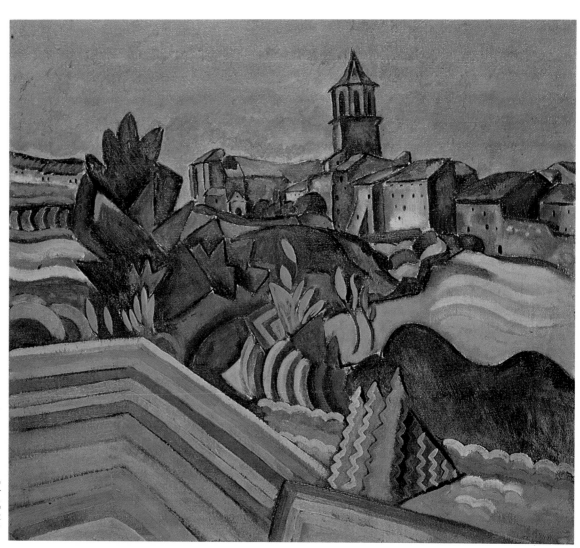

5. **Still Life with Coffee Mill,** 1918
 Oil on canvas, 62.5 x 70.8 (24⅝ x 27⅞)
 E. V. Thaw and Co., Inc., New York

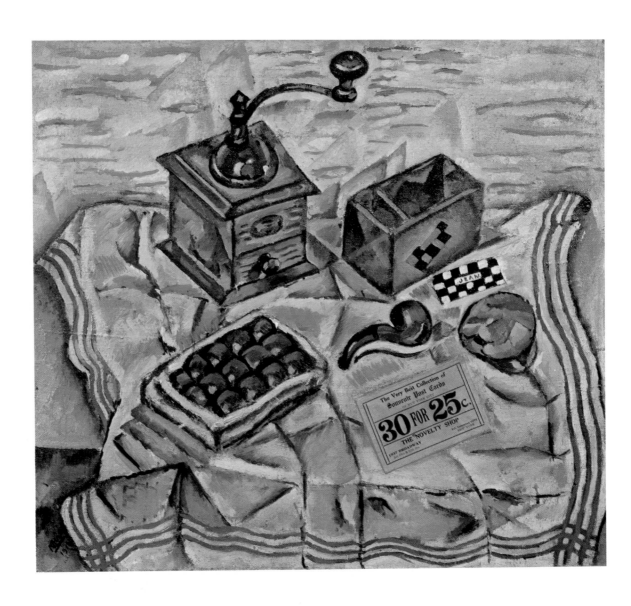

6. **Portrait of Ramon Sunyer,** 1918
Oil on canvas, 68.9 x 51.1 (27⅛ x 20⅛)
Private collection

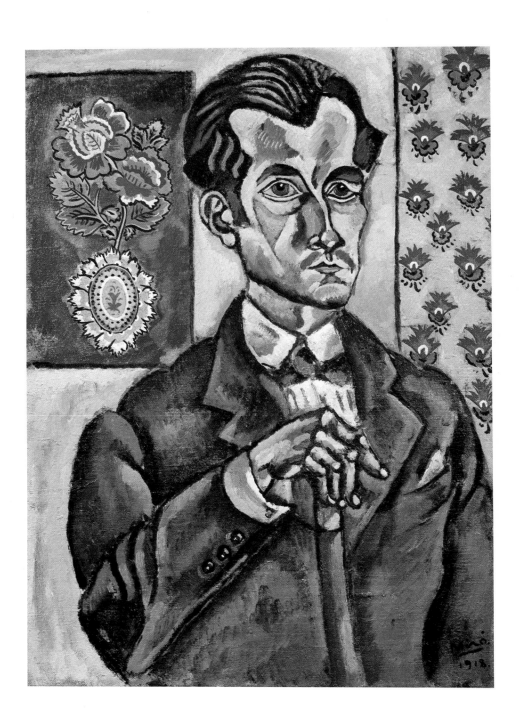

7. **Portrait of Juanita Obrador,** 1918
 Oil on canvas, 70 x 64.4 (27⅜ x 24⅜)
 The Art Institute of Chicago
 The Joseph Winterbotham Collection

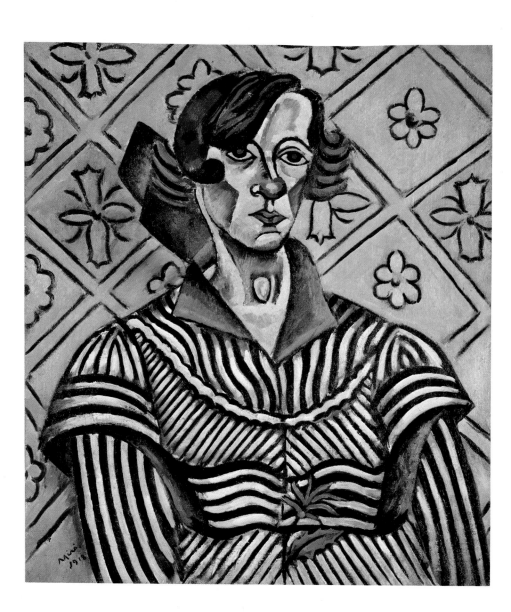

8. **Standing Nude,** 1918
Oil on canvas, 153 x 120.7 (59⅛ x 48)
The St. Louis Art Museum
Purchase: Friends Fund

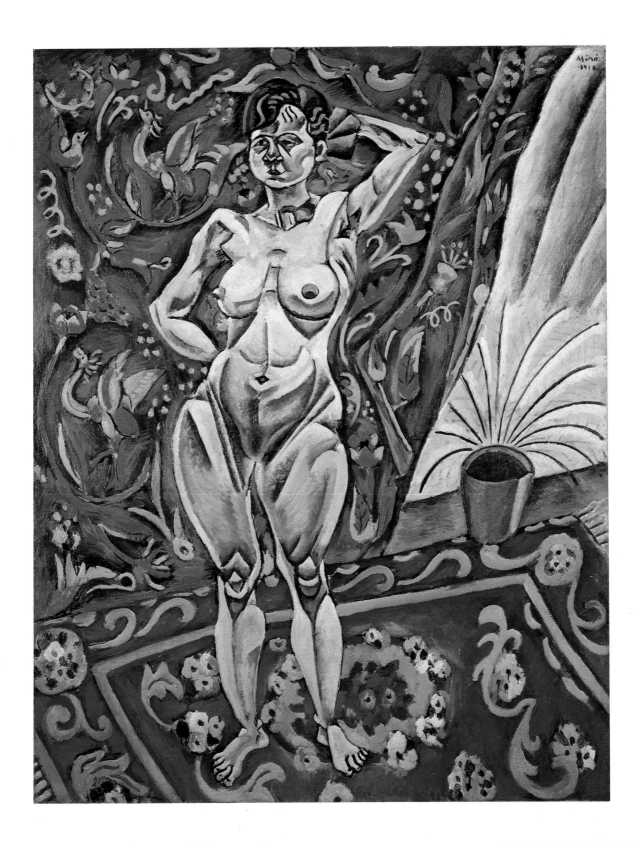

***9. The Farm,** 1921–22
Oil on canvas, 122.5 x 140.3 (48¼ x 55¼)
Ernest Hemingway, New York

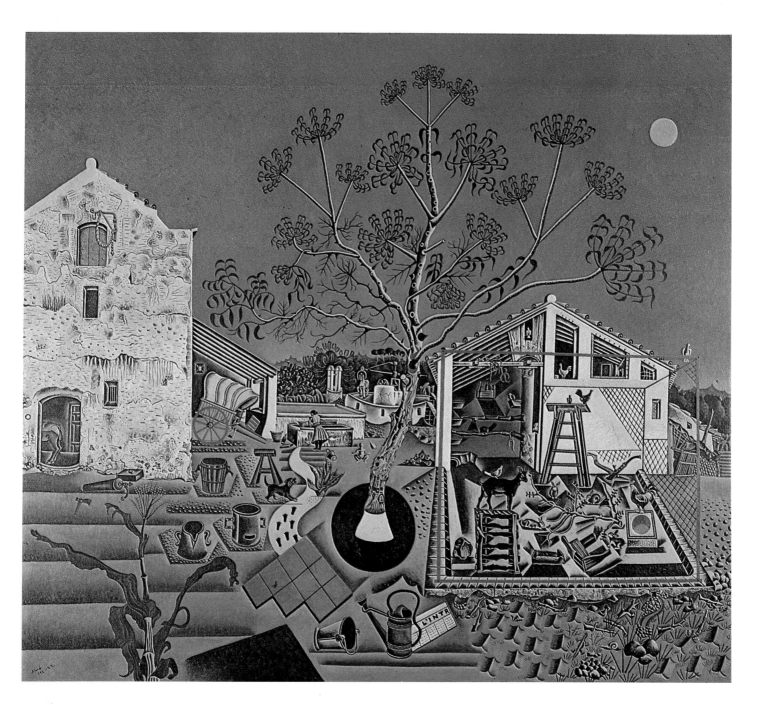

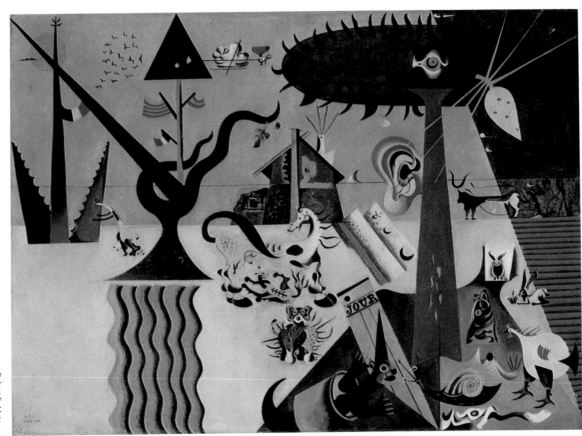

Robert E. Mates

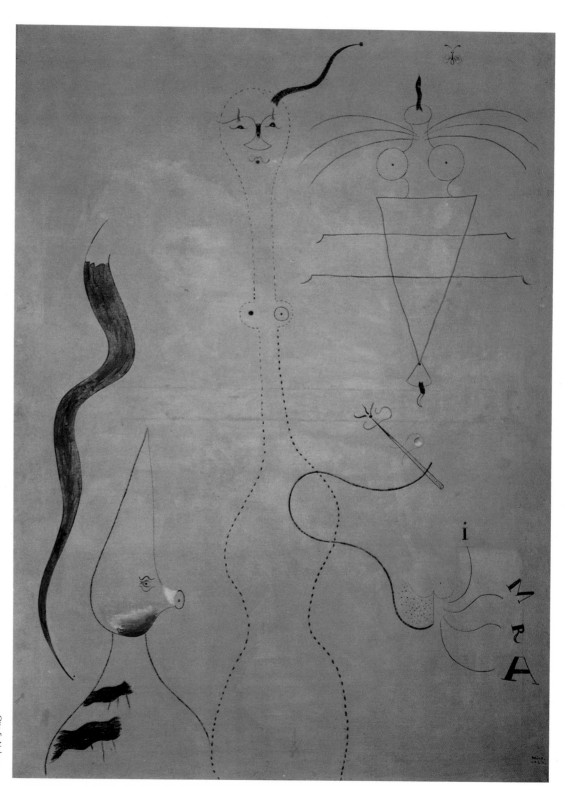

Otto E. Nelson

60

12. **Carnival of Harlequin,** 1924–25
Oil on canvas, 64.1 x 91.1 (26 x 36⅝)
Albright-Knox Art Gallery, Buffalo, New York
Room of Contemporary Art Fund

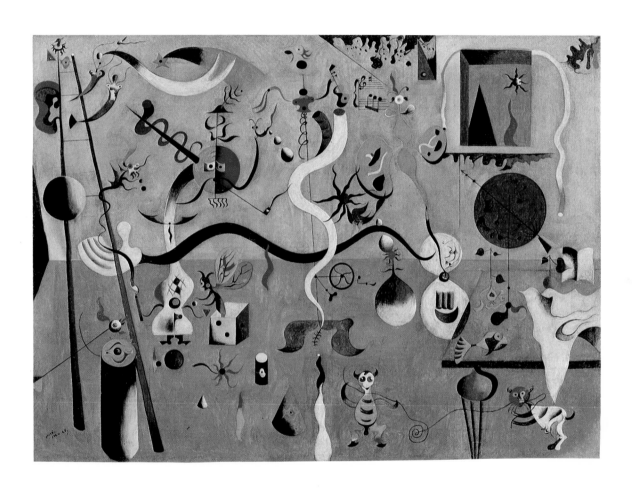

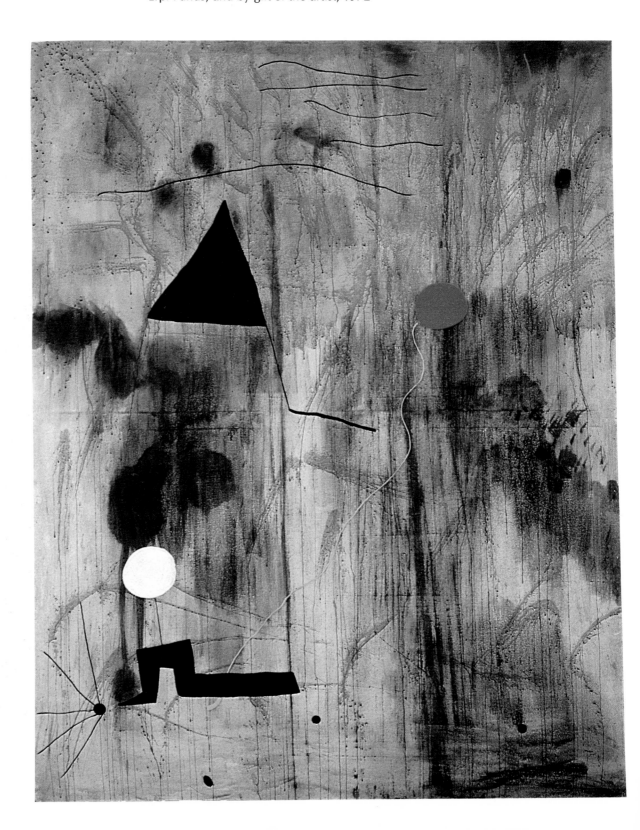

14. **Nude,** 1926
 Oil on canvas, 92.1 x 72.7 (36¼ x 28⅝)
 Philadelphia Museum of Art
 The Louise and Walter Arensberg Collection

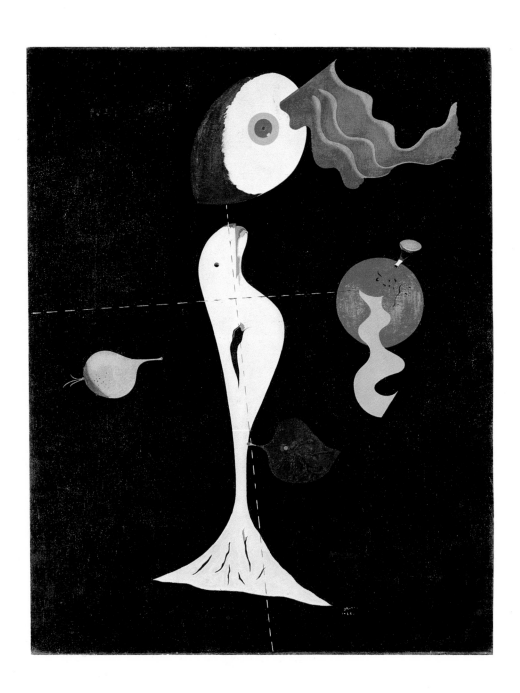

15. **Dog Barking at the Moon,** 1926
 Oil on canvas, 73 x 92.1 (28¾ x 36¼)
 Philadelphia Museum of Art
 The A. E. Gallatin Collection

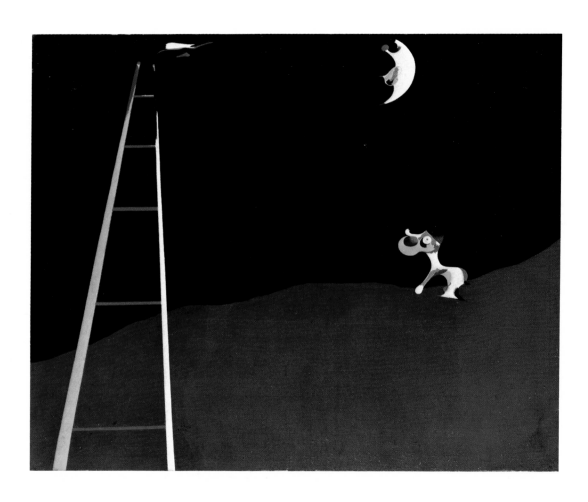

16. **Landscape,** 1927
 Oil on canvas, 129.9 x 194 (51⅛ x 76⅜)
 Collection of Mr. and Mrs. Gordon Bunshaft, New York

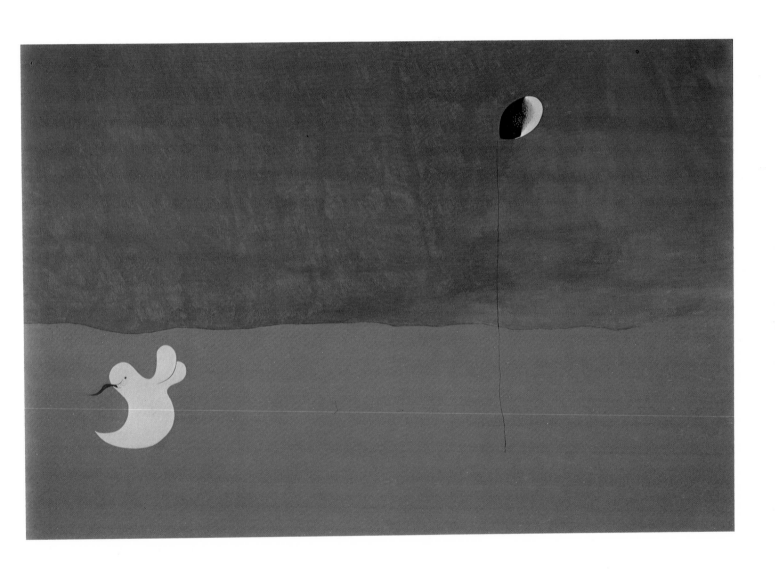

17. **Circus Horse,** 1927
Oil on canvas, 195 x 280 (76¾ x 110¼)
Hirshhorn Museum and Sculpture Garden, Smithsonian Institution,
Washington, D.C.

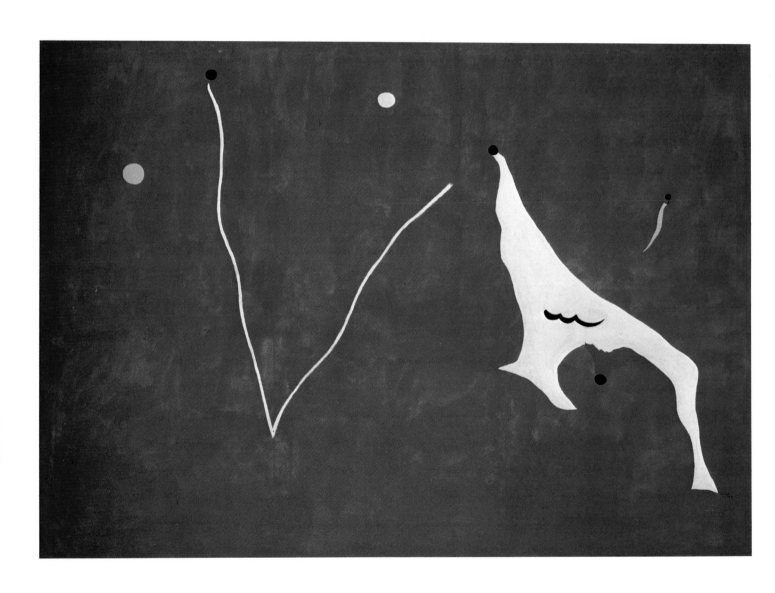

18. **Still Life with Lamp,** 1928
 Oil on canvas, 88.9 x 106.4 (35 x 44⅞)
 Private collection

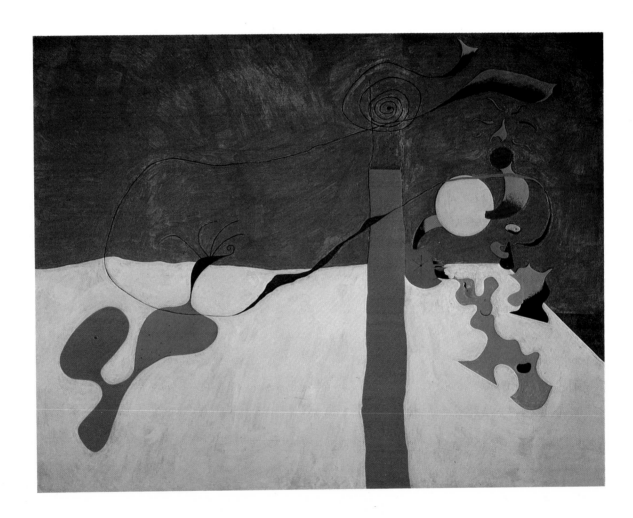

19. **Portrait of Mrs. Mills in 1750,** 1929
Oil on canvas, 114.5 x 88.9 (46 x 39¼)
The Museum of Modern Art, New York
James Thrall Soby Bequest, 1979

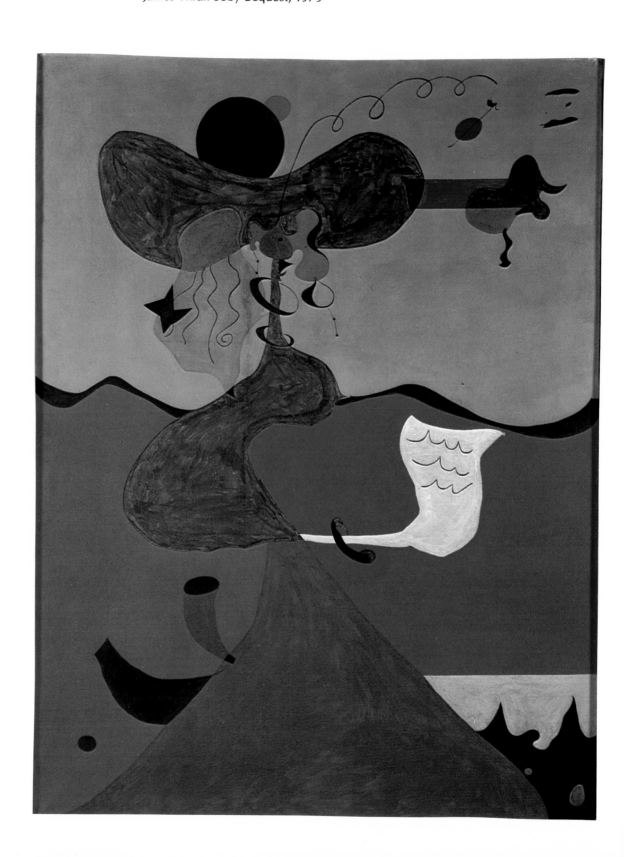

20. **Seated Woman,** 1932
 Oil on wood, 46 x 38.1 (18⅛ x 15)
 James Johnson Sweeney

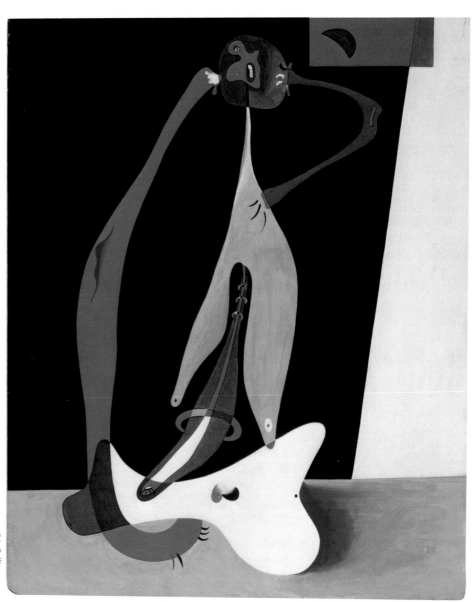

Eric Pollitzer

21. **Painting,** 1933
Oil on canvas, 130 x 162 (51⅛ x 63¾)
Perls Galleries, New York

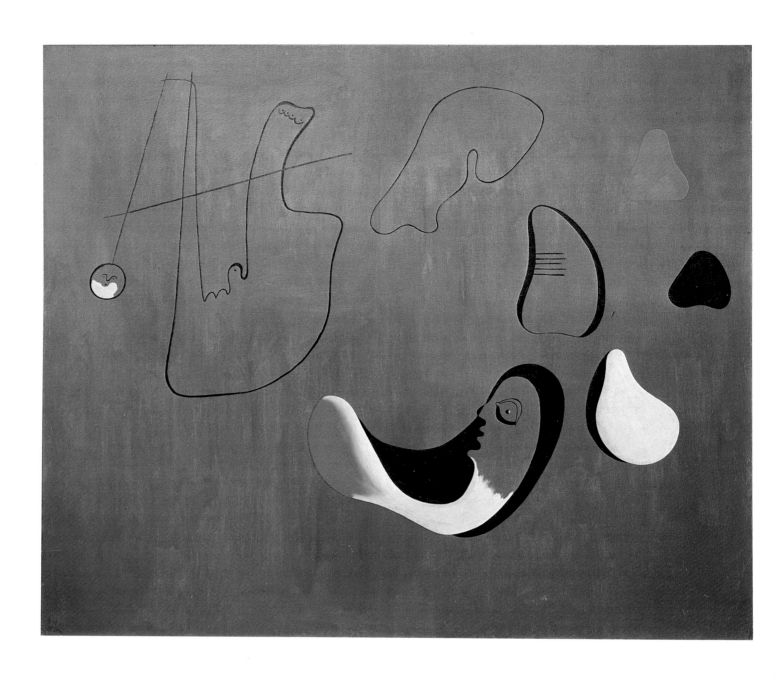

22. **Head of a Man,** 1935
Oil on paperboard, 106 x 75 (41¾ x 29½)
Private collection

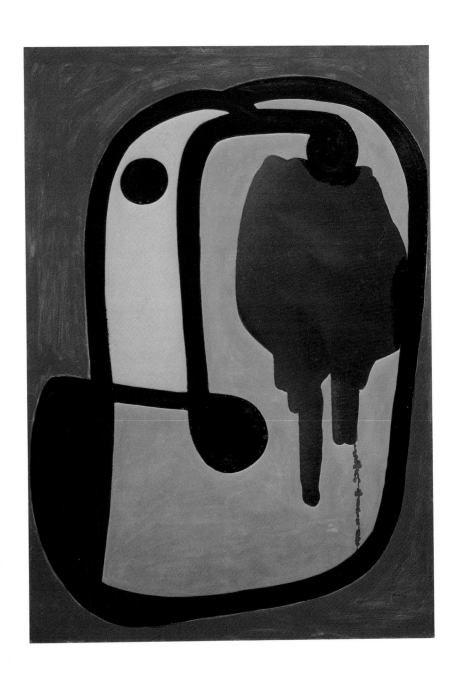

23. **Persons in the Presence of a Metamorphosis,** 1936
Egg tempera on Masonite, 49.9 x 57.2 (19⅝ x 22½)
Collection of the New Orleans Museum of Art
Bequest of Victor K. Kiam

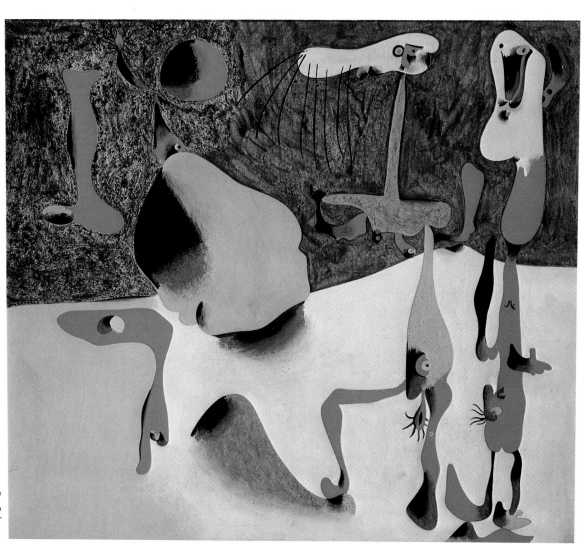

Roy Trahan

24. **Painting,** 1936
Oil and sand on Masonite, 78.8 x 107.3 (31 x 42¼)
Private collection

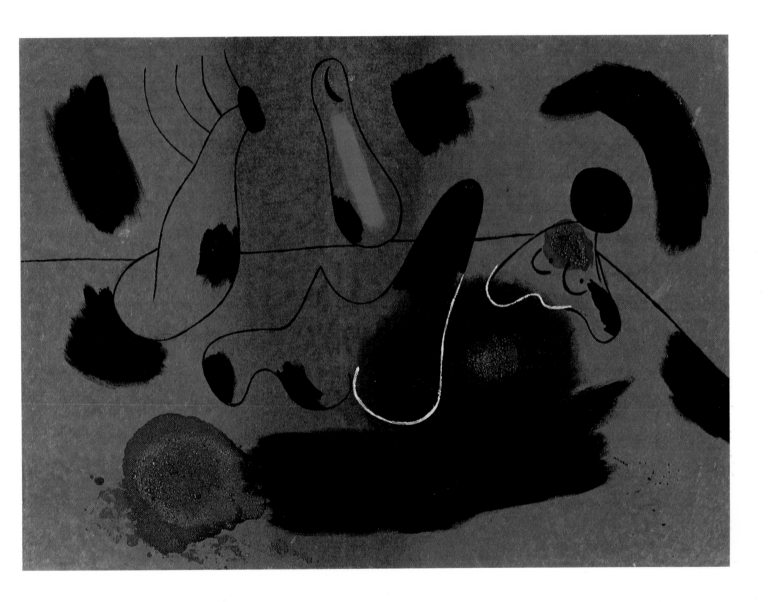

25. **The Circus,** 1937
 Oil on Celotex, 120 x 91.1 (47¼ x 35⅞)
 The Meadows Museum, Southern Methodist University, Dallas

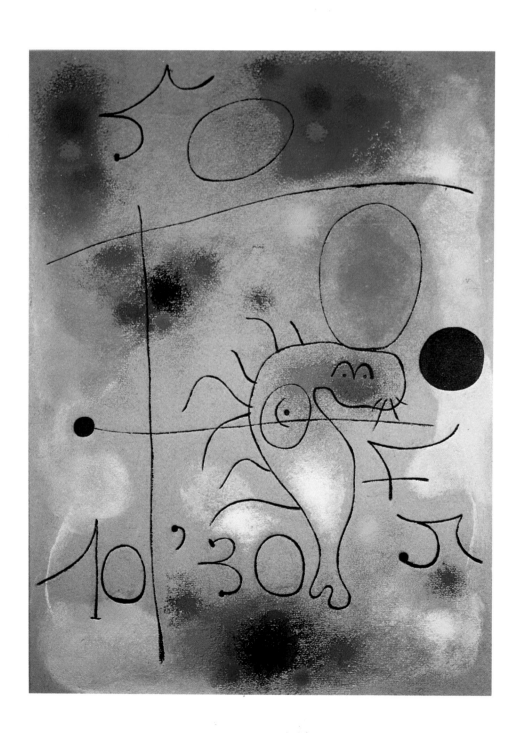

26. **Still Life with Old Shoe,** 1937
Oil on canvas, 87 x 117 (32 x 46)
The Museum of Modern Art, New York
James Thrall Soby Bequest, 1979

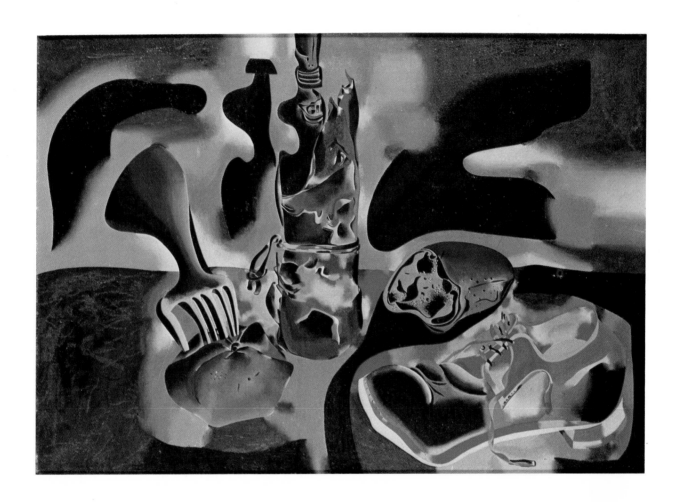

27. **Self-Portrait I,** 1937–38
 Pencil, crayon, and oil on canvas, 146.1 x 97.2 (57½ x 38¼)
 The Museum of Modern Art, New York
 James Thrall Soby Bequest, 1979

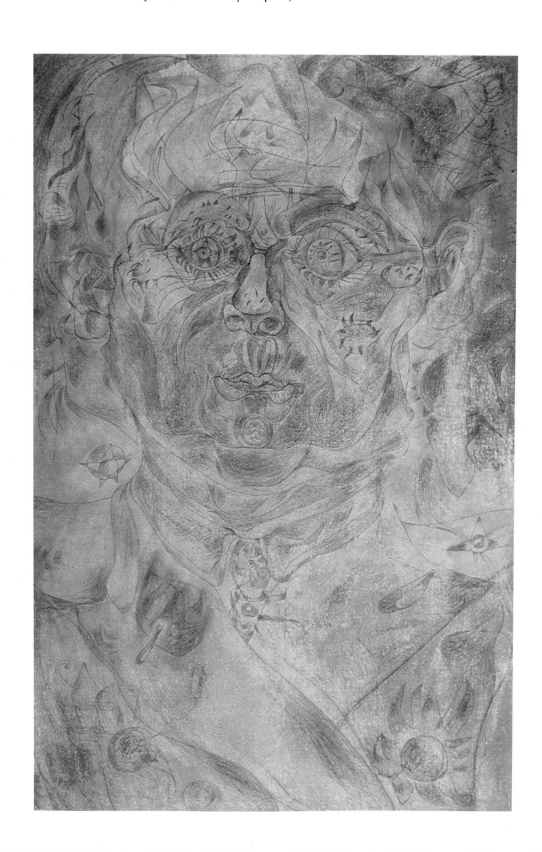

28. **Self-Portrait II,** 1938
Oil on canvas, 129.5 x 185.6 (51 x 77)
The Detroit Institute of Arts
Gift of W. Hawkins Ferry

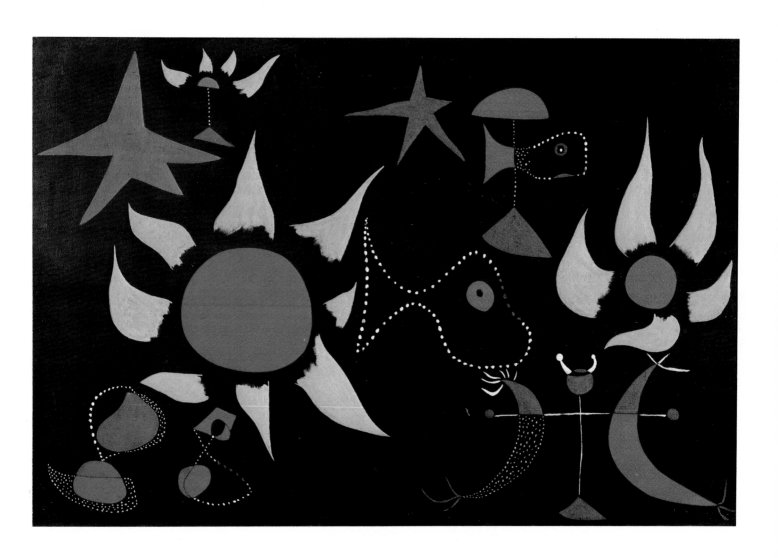

29. **Une étoile caresse le sein d'une négresse (A Star Caresses the Breast of a Black Woman),** 1938
Oil on canvas, 129.9 x 195.9 (51⅛ x 77⅛)
Pierre Matisse Gallery, New York

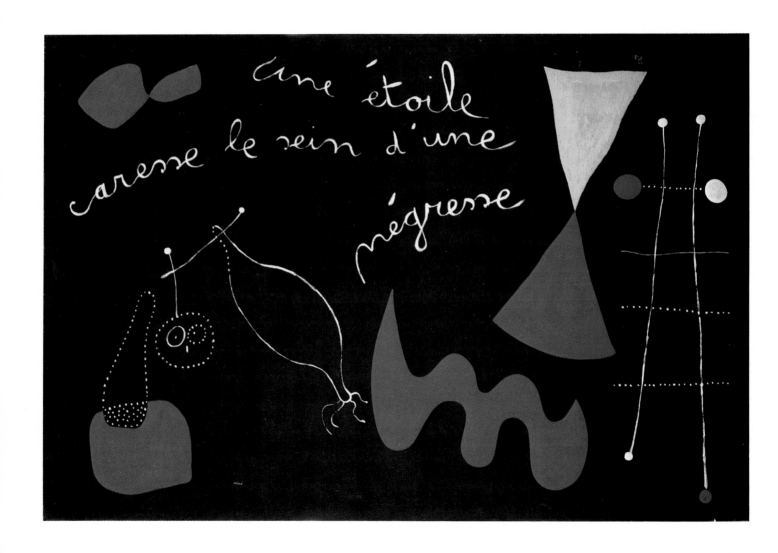

30. **A Drop of Dew Falling from the Wing of a Bird Awakens Rosalie Asleep in the Shadow of a Cobweb,** 1939
Oil on burlap, 65.4 x 91.8 (25¾ x 36⅛)
The University of Iowa Museum of Art, Iowa City

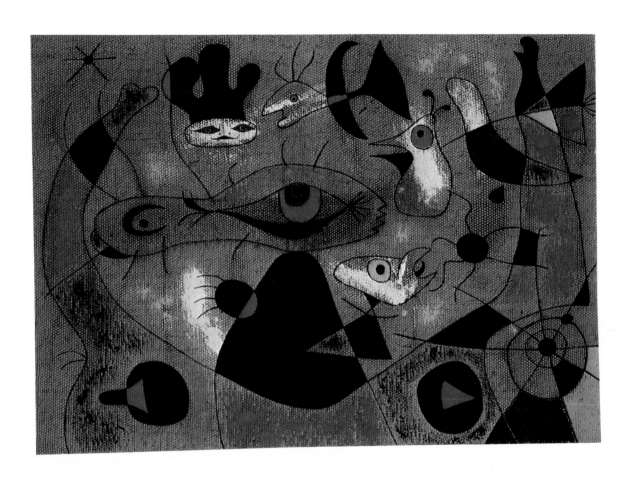

31. **The Nightingale's Song at Midnight and Morning Rain,** 1940
Gouache and oil wash on paper, 38 x 46 (15 x 18⅛)
Perls Galleries, New York

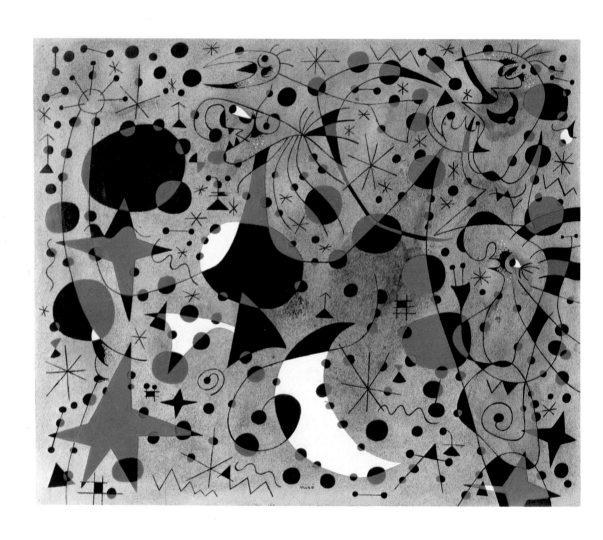

32. **Acrobatic Dancers,** 1940
 Gouache and oil wash on paper, 46 x 38 (18⅛ x 15)
 Wadsworth Atheneum, Hartford, Connecticut
 The Philip L. Goodwin Collection

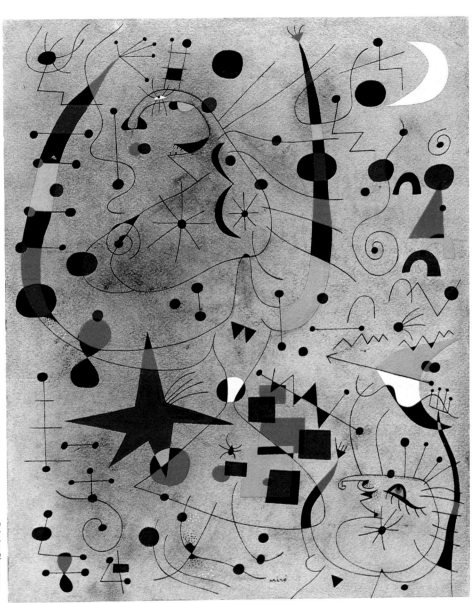

E. Irving Blomstrann

33. **The Harbor,** 1945
Oil on canvas, 130 x 162 (51⅛ x 63¾)
Mr. and Mrs. Armand Bartos, New York

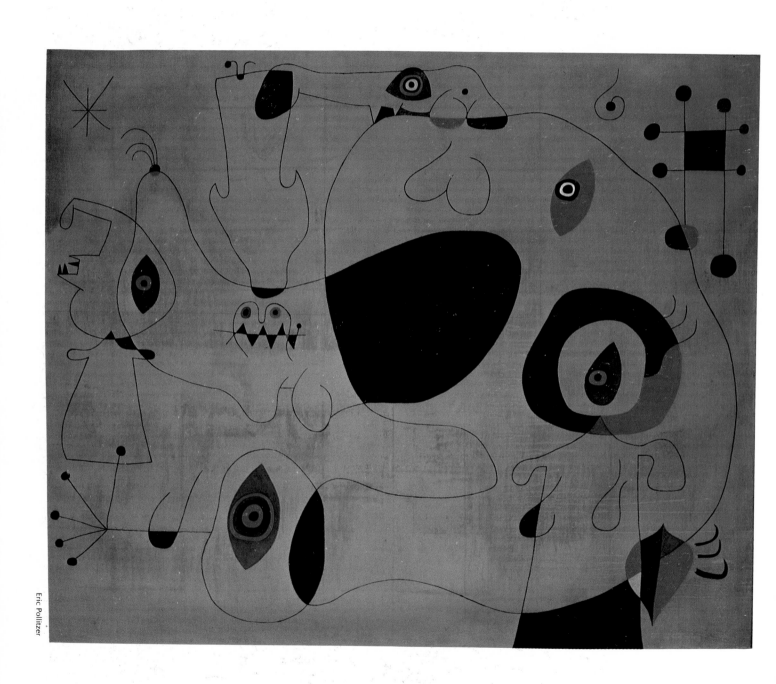

Eric Pollitzer

34. **Woman and Little Girl in Front of the Sun,** 1946
Oil on canvas, 143.5 x 114 (56½ x 44⅞)
Hirshhorn Museum and Sculpture Garden, Smithsonian Institution,
Washington, D.C.

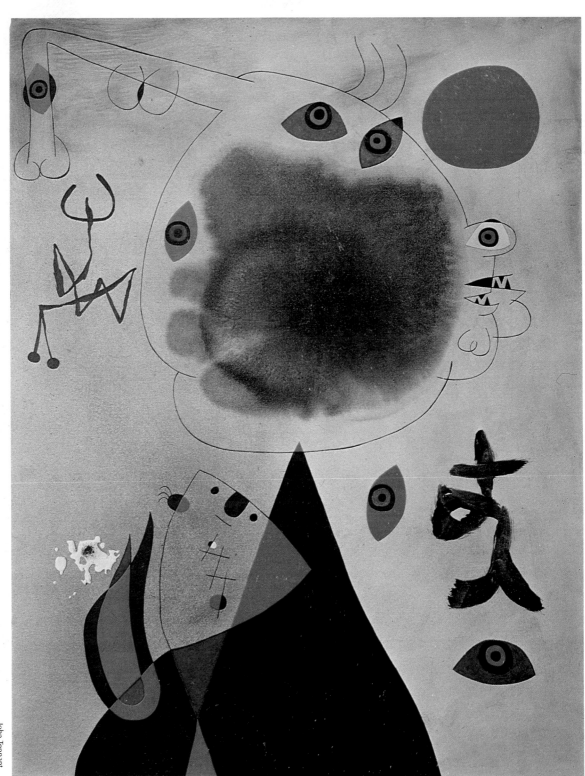

John Tennant

83

35. **Painting,** 1950
Oil on canvas, 80 x 100 (31½ x 39⅜)
Collection of Mr. and Mrs. Gordon Bunshaft, New York

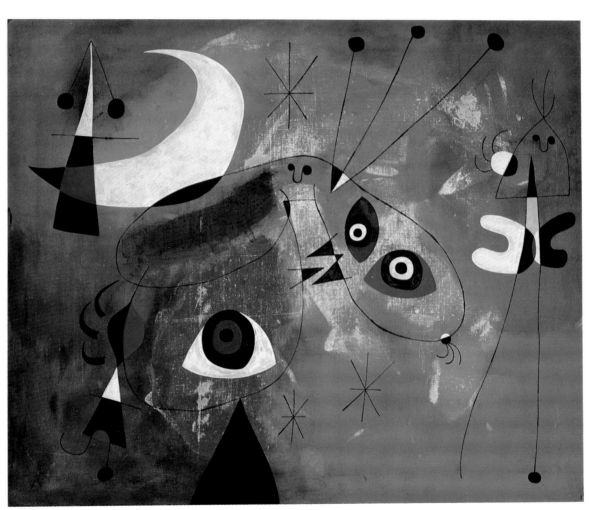

Eric Pollitzer

36. **Painting,** 1953
Oil on canvas, 245 x 125 (96½ x 49¼)
Pierre Matisse Gallery, New York

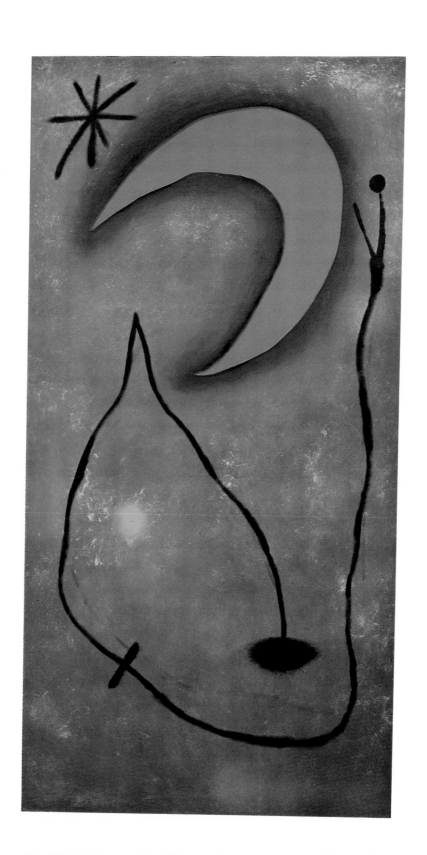

37. **The Red Disk,** 1960
 Oil on canvas, 129.9 x 165.1 (51⅛ x 65)
 Collection of New Orleans Museum of Art
 Bequest of Victor K. Kiam

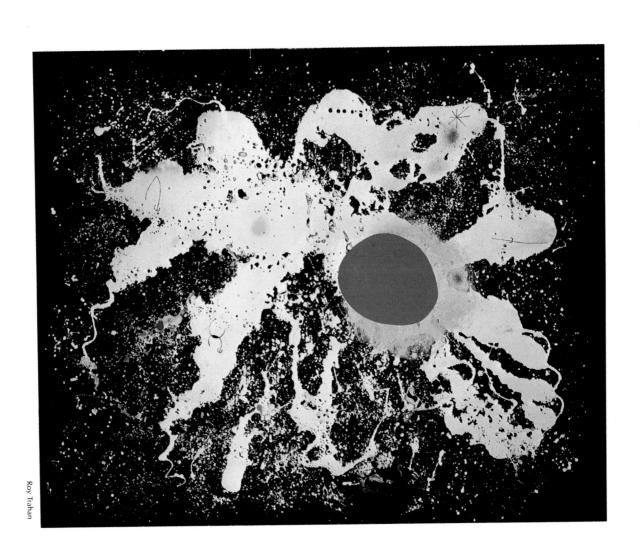

Roy Trahan

38. **Blue II,** 1961
 Oil on canvas, 270 x 355 (106¼ x 139¾)
 Pierre Matisse Gallery, New York

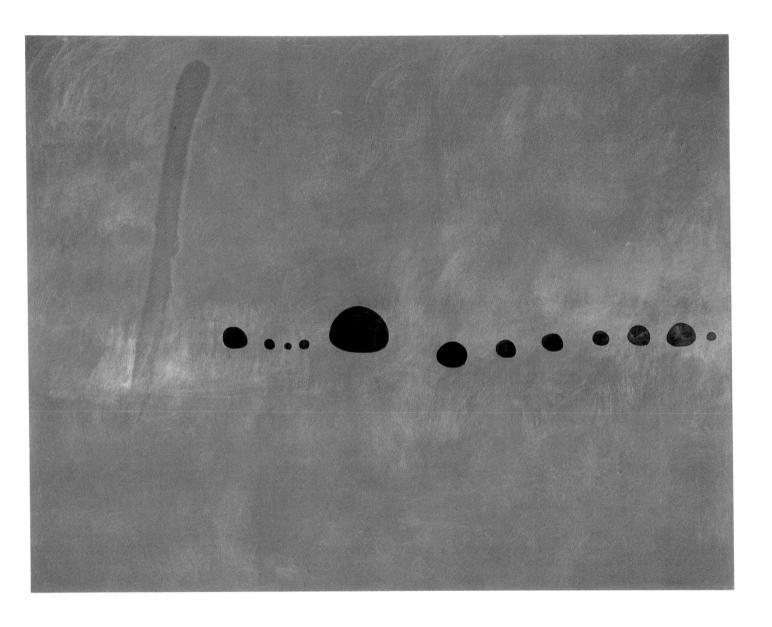

First Spark of Day III, 1966
Oil on canvas, 146.1 x 111.3 (57½ x 45)
Carimati Collection, New York

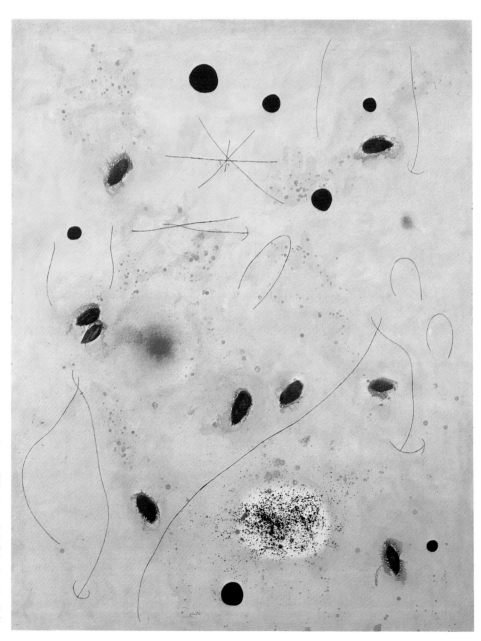

40. **Woman before an Eclipse with Her Hair Disheveled by the Wind,** 1967
Oil on canvas, 240 x 195 (94½ x 76¾)
Pierre Matisse Gallery, New York

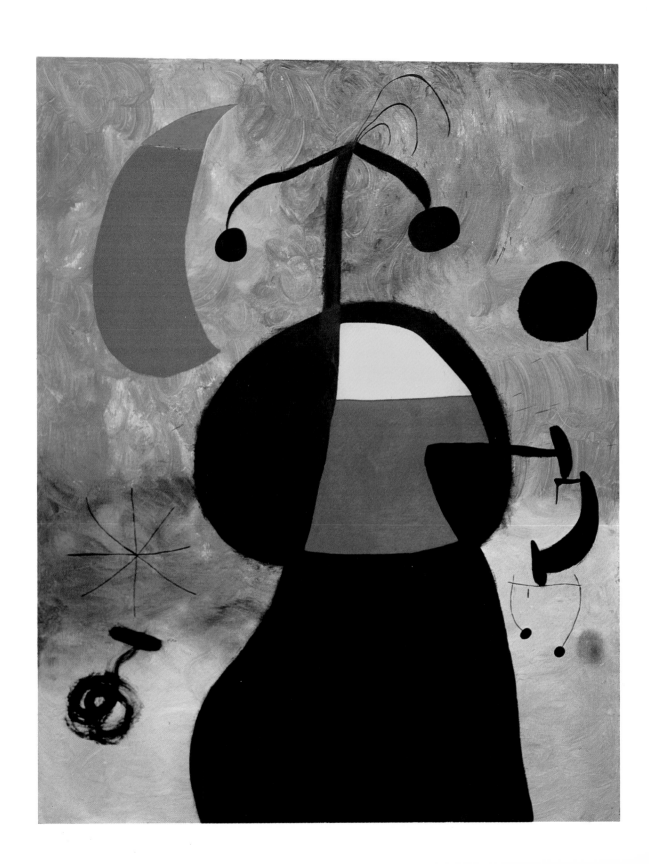

41. **Hair Pursued by Two Planets,** 1968
Oil on canvas, 195 x 130 (76⅞ x 51¼)
Pierre Matisse Gallery, New York

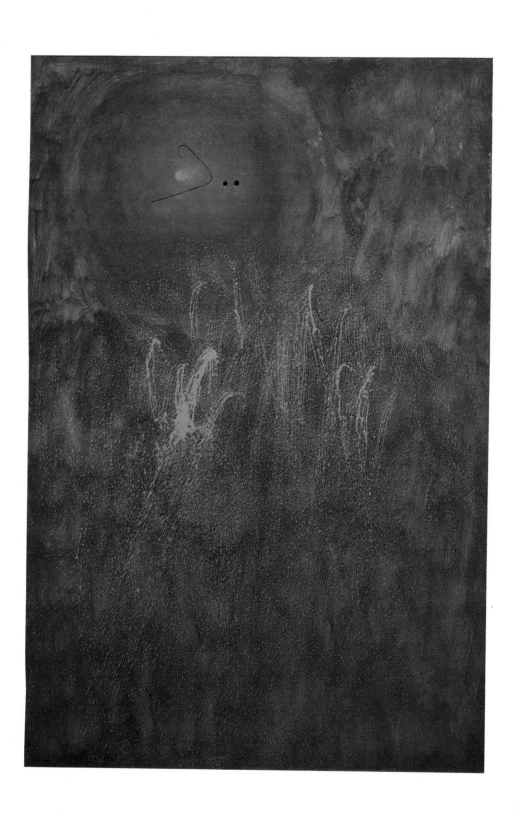

42. **Birds at the Birth of Day,** 1970
Oil on canvas, 219.7 x 261.6 (86½ x 103)
Pierre Matisse Gallery, New York

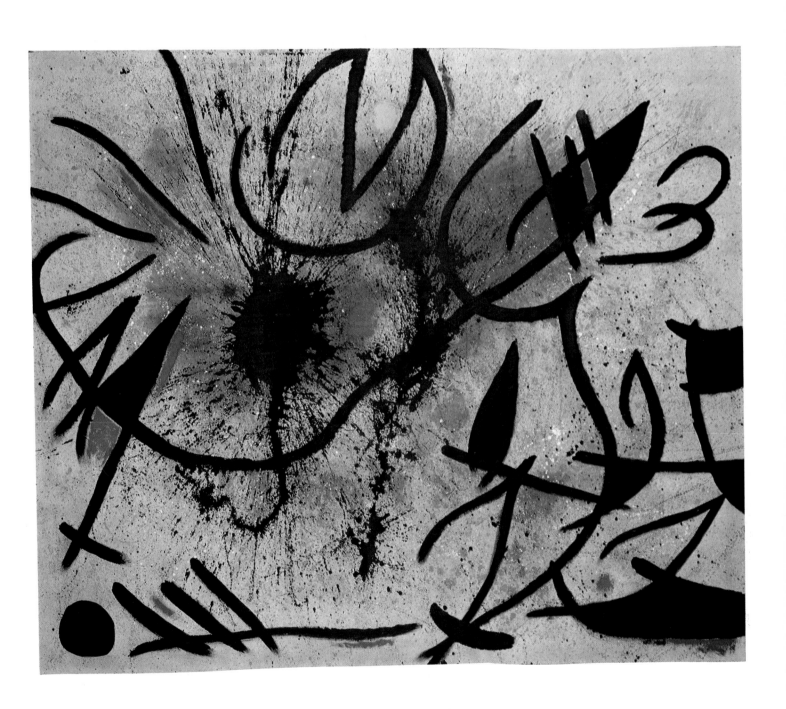

43. **Toward the Escape,** 1972
 Oil on canvas, 97.2 x 73 (36½ x 28¾)
 Annette Mandel Inc., Great Neck, New York

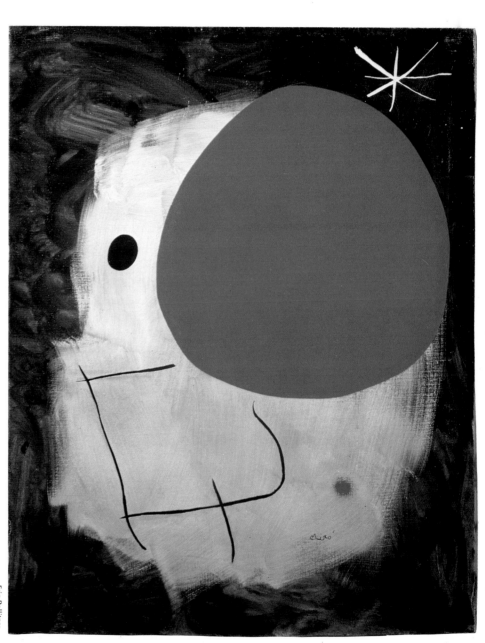

Eric Pollitzer

45. **Bird, Insect, Constellation,** 1974
Oil on canvas, 130 x 96.5 (51 x 38)
Pierre Matisse Gallery, New York

This book was produced by the Smithsonian Institution Press, Washington, D.C. Printed by Garamond Pridemark Press, Inc., Baltimore, Md. Set in 10/15 VIP Optima by Composition Systems Inc., Arlington, Va. The paper is Warren's Lustro Offset Enamel Gloss, eighty-pound text and one-hundred-pound cover. Designed by Elizabeth Sur.